Facing the Light

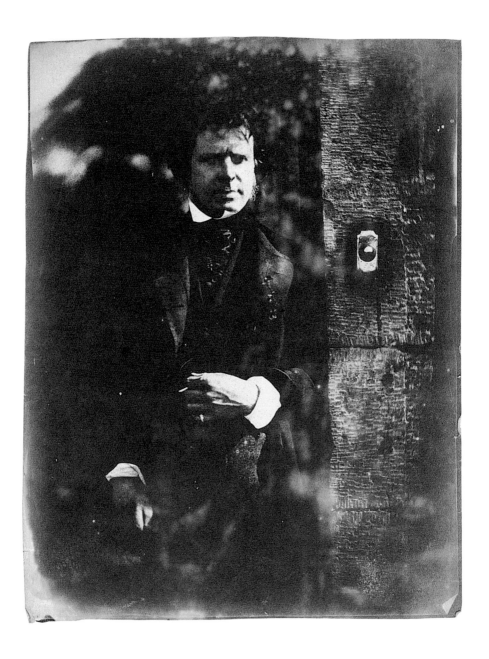

Sara Stevenson

Facing the Light

The Photography of Hill & Adamson

Scottish National Portrait Gallery
Edinburgh 2002

SPONSORED BY

 Lloyds TSB
Scotland

Published by the Trustees of the National
Galleries of Scotland on the occasion of the exhibition
Facing the Light: The Photography of Hill & Adamson
held at the Scottish National Portrait Gallery,
Edinburgh, from 10 May to 15 September 2002.

© The Trustees of the National Galleries of Scotland

ISBN 1 903278 32 5

Designed by Dalrymple
Typeset by Brian Young in Fournier and Clarendon
Copy photography by Antonia Reeve
Printed in Belgium by Snoeck-Ducaju & Zoon

Front cover: Alexander Rutherford, William Ramsay
and John Liston [61]

Back cover: Mary Campbell, Lady Ruthven [55]

Frontispiece: David Octavius Hill

Contents

Foreword

The National Galleries of Scotland's debt to David Octavius Hill lies in his work as an artist and in his generous promotion of the arts in Scotland. As secretary of the Royal Scottish Academy for forty years, he was, in part, responsible for the establishment of the National Gallery of Scotland in 1850. His specific role as an artist finds its greatest and most original focus in the partnership with Robert Adamson in the four years between 1843 and 1847. During this short time, Hill and Adamson not only produced some of the most beautiful and enduring images in the history of photography but also influenced generations of later photographers.

The year 2002 is the bicentenary of the birth of David Octavius Hill and *Facing the Light* is the centrepiece of a nationwide festival celebrating his remarkable achievements. The photographs included in this book and the accompanying exhibition come from the Scottish National Photography Collection at the Scottish National Portrait Gallery, which holds the world's largest and most important archive of Hill and Adamson's work. This collection has largely been amassed through a series of magnificent donations and we wish to record an enormous debt of gratitude to The Edinburgh Photographic Society; Andrew Elliot; James Brownlee Hunter; Mrs Peggy Notman; Mrs Ann Riddell, whose gift was in memory of her husband Peter Fletcher Riddell; and Mrs Elizabeth Uldall.

Facing the Light is part of the Lloyds TSB Scotland Year of Photography at the National Galleries of Scotland and we would like to acknowledge their generous support.

As always, we are indebted to the generosity of our knowledgeable colleagues outside the National Galleries in assisting our work. We would also like to thank the staff of the National Galleries of Scotland for their contributions, in particular, Sara Stevenson, whose research over many years has added significantly to our knowledge of the remarkable partnership between David Octavius Hill and Robert Adamson.

MICHAEL CLARKE

Acting Director-General
National Galleries of Scotland

JAMES HOLLOWAY

Director
Scottish National Portrait Gallery

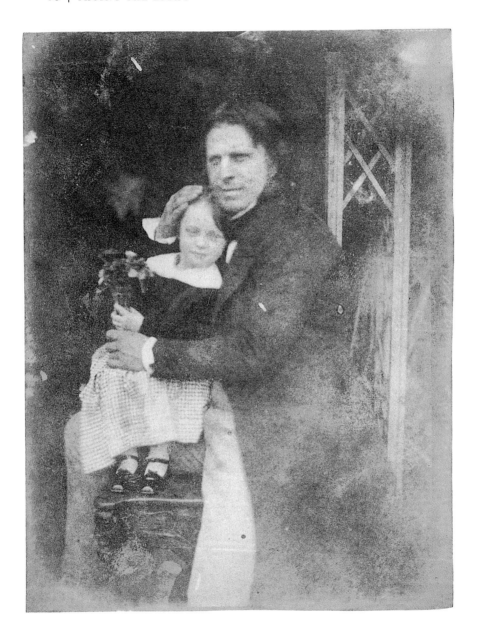

David Octavius Hill and Robert Adamson

David Octavius Hill (1802–1870) was born in the middle of a major European war. In 1802, the British had been fighting the French for ten years, and the conflict was not to end for a further thirteen years, until the final and bloody Battle of Waterloo in 1815. A whole generation had learnt to live with the conditions of hostility and its effects. Both phases of the war, with the revolutionary republican forces and then with the Emperor Napoleon, had profound consequences in Scotland. The Scottish judge, Lord Cockburn (1779–1854), wrote of a time obsessed with the violence of the French Revolution:

> *Everything rung, and was connected with the Revolution in*
> *France; which, for above 20 years, was, or was made, the all in*
> *all. Everything, not this or that thing, but literally everything,*
> *was soaked in this one event ... No innovation, whether political*
> *or speculative, consequently no political or economical reformer,*

[1] D.O. Hill and his Daughter, Charlotte, 1843

Hill's first wife, Ann Macdonald, died in 1841, leaving him a widower with an only child, Charlotte, nicknamed Chatty. This photograph combines a practical way of holding the child still, with a sense of the loving affection Hill felt for his daughter.

and no religious dissenter, from the Irish Papist to our own
native Protestant Seceder, could escape ... the suppression of
independent talent or ambition was the tendency of the times.[1]

The end of the war offered a release from restrictions, which had both ob-
structed and sheltered people from change. The young Hill's approach to
the adult world was suddenly open to new ideas and possibilities and, in the
eyes of the political opposition, change was radical in all areas from politics
to religion, to the arts. It was an extraordinary time: heir not just to the In-
dustrial Revolution, but to the appalling discovery that industrial slumps
were a natural part of this revolution; a time which opened a new freedom
for the individual, but which coincided with a population explosion, turn-
ing Britain from a country predominantly rural into a country predomi-
nantly based in the cities, and resulting in the worst of slum life.

Cockburn's account of the years after the middle and end of the war
offers an astonishing range of change in all fields. Amongst the first and most
impressive of these changes was the great literary revolution begun by
Archibald Constable, the publisher of the *Edinburgh Review* and the works
of Sir Walter Scott (1771–1832), who:

rushed out and took possession of the open field, as if he had been
aware from the first of the existence of the latent spirits, which a
skilful conjurer might call from the depths of the population to
the service of literature ... he stood out as the general patron and
payer of all promising publications, and confounded not merely
his rivals in trade, but his very authors, by his unheard-of prices
... [which] made Edinburgh a literary mart, famous with
strangers, and the pride of its own citizens.[2]

Hill was the son of a Perth bookseller, and his art both reflected literature
and was consciously directed towards publication. His first known artwork,
produced when he was eighteen, was a series of lithographs called *Sketches*
of Scenery in Perthshire.

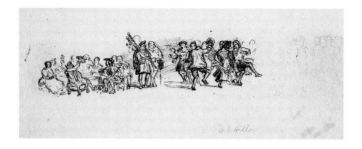

[2] **D. O. Hill 'Figures Dancing'**

Although Hill is generally known as a
landscape painter, he was also interested in
animating his paintings with active people. The
great difficulty of capturing the relationships
within a group, was one of Hill's driving
interests in his partnership with Adamson.

[3] **D. O. Hill 'On the Quay at Leith'**

This small painting combines Hill's interests in
shadow, light and movement in a scene essentially
human and local. Note the two boys working the
puppets on the right. Hill's readiness to use a
slanting light, filtered and obstructed by the boats'
sails, reappears later in his photography.

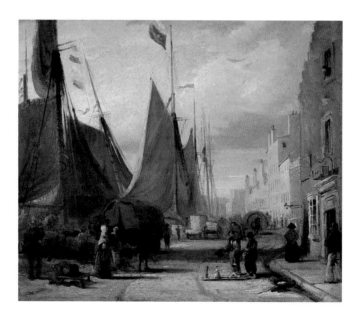

Hill came to Edinburgh to study painting when he was about sixteen. He undertook both genre and landscape painting and generally combined the two, so that his landscapes are inhabited [**2 & 3**]. In 1832, he showed a further interest in technology, by publishing a set of lithographs of the newly-built Glasgow and Garnkirk Railway. The railway engineer, John Miller, was a friend and became an important patron of Hill's work. In the same year, Hill took on the role of secretary of the Scottish Academy, putting him in a key professional position, and involving him in considerable and imaginative work to promote the arts in Scotland. For the first five years he undertook the work unpaid, which may have delayed his marriage to Ann Macdonald, which took place in 1837. She was a member of a wine merchants' family from Perth, and is said to have been a fine musician. Their child, Charlotte, was born in 1839, but Ann herself died in 1841, leaving Hill a widower [**1**].

In the mid-1830s, Hill undertook a series of sixty landscape paintings relating to the life and writings of Robert Burns (1759–1796), which was published in book form as *The Land of Burns*, in 1840. While Hill was completing this project, photography became a practical proposition. The first successful form was the French daguerreotype, announced in January 1839. This was a clearly-detailed process, in which the image was made in grains of silver on a polished copper plate. Louis-Jacques-Mandé Daguerre's announcement of this process was rapidly followed by the further declaration by the Englishman, William Henry Fox Talbot (1800–1877), of his photogenic drawing; unlike the daguerreotype, it was made on paper, sensitised with nitrate of silver, and had a negative capable of making many prints. Although Talbot had been working on the idea for some years, he had been hurried by the French publicity, and his first version of photography was far behind in quality. The Scottish scientist, James David Forbes (1809–1868), who examined the two processes, was enchanted by the daguerreotype and unimpressed by the photogenic drawing and wrote:

The daguerrotype baffles belief ... in beauty, and the perfect
representation of nature it must be seen to be understood ... As to
Messrs. Talbot & Co. they had better shut up shop at once.[3]

Talbot made the critical breakthrough in 1840. He discovered that, while sunlight would print a visible image on treated paper over a long period of time, possibly hours, within a much shorter time, minutes or even seconds, it made an invisible, or 'latent' image, which could be developed out by gallic acid. This discovery made photographing people a practical proposition, and caused Talbot to re-christen his process 'the calotype', which means beautiful print [**4 & 5**].

Forbes worked at the University of St Andrews, alongside the physicist, Sir David Brewster (1781–1868), who had specialised in the study of optics and light [**6**]. Brewster was a friend of Talbot, and photography was naturally of interest. Brewster's circle in St Andrews was among the earliest to practise photography, and they were apparently successful in making daguerreotypes. But it was only after a long struggle, that Brewster's colleague, Dr John Adamson (1809–1870), took his first successful calotype portrait in May 1842. Adamson discovered how to control a process that remained remarkably difficult. He then worked rigorously with Robert Adamson (1821–1848), his young brother [**7**], who became, in Brewster's words, 'well-drilled in the art'.

A later account of Robert Adamson's youth, explained his readiness to adopt this profession:

As a boy he was delicate in health and retiring in disposition,
with a strong turn for the natural sciences, and an especial
aptitude for mechanics; devoting all his spare time to the
construction of various models, steam-engines, wheelbarrows and
small schooners which he sailed on the burn that ran beside his
father's house, and sometimes even building larger rowing-boats,
to the no small danger, as we are informed, of those who ventured

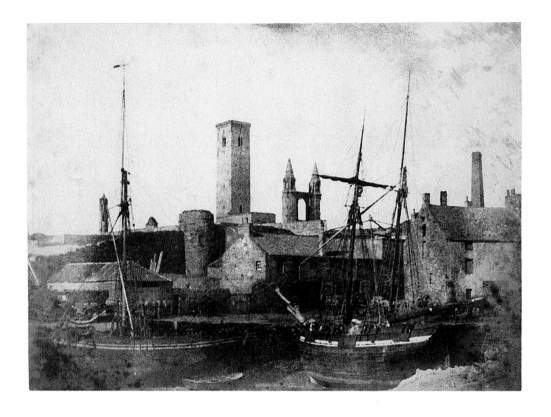

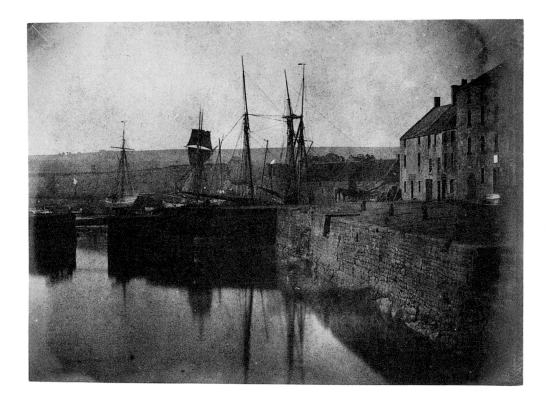

[4 & 5] The Harbour, St Andrews

In the late 1830s, the university town of St Andrews was a decayed
backwater, cut off from the mainstream of Scottish life – the
university reduced, and the fishing industry depressed. In the
course of the 1840s, the town was developed and reformed. It
became a fashionable health resort, focused on the sport of golf.
The Adamson brothers had used the town as a testing place for
photography, taking photographs of the monuments at different
times and in different lights. These harbour photographs are likely
to have been taken by Hill and Adamson for their series, *The
Fishermen and Women of the Firth of Forth.*

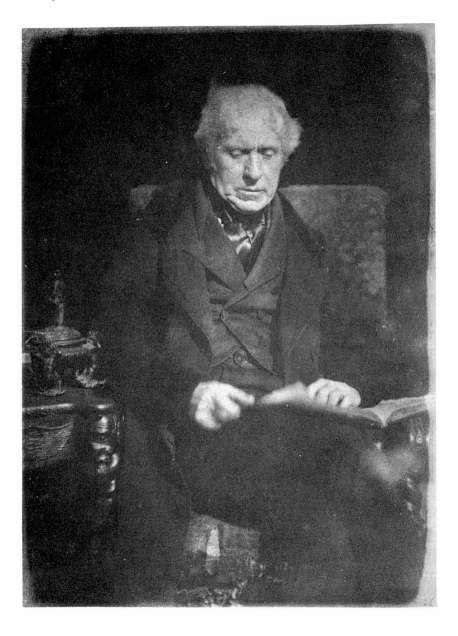

their persons therein upon the deep. At one time it seemed
probable that he would adopt mechanics as a profession; and,
indeed, with this in view, he worked for a year or two in a mill-
wright and engineer's shop in Cupar, but his frame was hardly
muscular enough, his health scarcely sufficiently robust to bear
the severe physical strain involved in such a calling.[4]

The new art of photography seemed an excellent alternative career. Talbot did not patent the calotype in Scotland, and agreed to Robert Adamson setting up in business in Edinburgh. Adamson moved to the city on 10 May 1843, where he rented Rock House, the highest sited private house, on Calton Hill in the New Town, with a south-facing walled garden offering the maximum of light and shelter.

Adamson had arrived in Edinburgh on the eve of a great public drama, and his arrival went unremarked. On 18 May, the annual General Assembly of the Church of Scotland was scheduled to open, and it was public knowledge that it would be the stage of a formal protest against political control of the Church's affairs. The leading ministers of the Church had fought a long, well-organised battle for its freedom. It was certain that some of the ministers would abandon their livings on principle; it was not known in advance how many ministers would leave. Mrs Oliphant recorded that:

[6] Sir David Brewster

David Brewster was a highly distinguished physicist, who invented the kaleidoscope and one version of the stereoscopic camera. He was both a highly stimulating companion and a man of fearsome argumentativeness. Lord Cockburn wrote of him: 'He lives in St Andrews and presides over its principal college, yet no-one speaks to him! With a beautiful taste for science, he has a stronger taste for making enemies of friends. Amiable and agreeable in society, try him with a piece of business, or with opposition, and he is instantly, and obstinately, fractious to the extent of something like insanity.'

*By four o'clock in the morning, eager spectators had begun
to fill the church in which the Assembly's deliberations were held,
and the streets were crowded with a surging mass of people...
One can feel the rustle yet hush of that crowd when, after a few
minutes of breathless expectation, occupied within by necessary
formalities, a rustle of movement was heard, and the well known
white head and pale impressive heavy countenance of Thomas
Chalmers became suddenly visible, with the Moderator in his
robes by his side, issuing from the door: and behind him an
endless line, figure after figure, appearing like an army. The
crowd held its breath, then breaking into tumultuous cheers,
opened a narrow line in which three men could walk abreast, in
the ever-lengthening line: and soon that dark and silent
procession, a quarter of a mile long, wound on between these
living walls, recognized, shouted over, cheered with the wild
outcries of unrestrainable emotion along the whole course of the
way. More than four hundred ministers walked in that line,
leaving their all in this world – their incomes, their positions,
their homes – behind them for ever.*[5]

The meeting had been opened by the moderator, the Revd Dr David Welsh
(1793–1845), who rose, simply delivered the formal protest, and walked out,

[7] The Adamson Family

This picture of the Adamson family shows Dr John Adamson on
the left, Alexander Adamson, who took on the family farm at
Burnside, their sister, Melville Adamson, and Robert on the right.
Hill wrote under this calotype: 'Dr John Adamson of St Andrews
was one of the earliest and most skilful improvers of the processes
of the Calotype. His brother Robert devoted himself, with my aid
as an artist, in developing the powers of the art.'

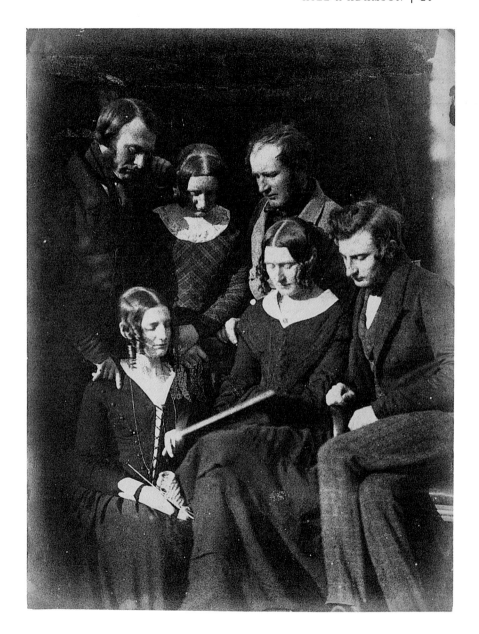

followed by the ministers and a larger group of the Church elders. Down the hill at Tanfield Hall (an old oil and gas works), they established the Free Church, independent of the state. This was the great nationalist event of the nineteenth century.

Hill was amongst those present. He was deeply impressed, and determined to celebrate this great historic action in a painting. He gained the permission and encouragement of the Free Church moderator, the Revd Dr Thomas Chalmers (1780–1847), and began to sketch the proceedings. But Hill was faced with the immense problem of drawing such a crowd of ministers, elders and women. How was he to capture the appearance of hundreds of people? His first idea was to picture Chalmers preaching [**9**]. It was then suggested that he paint the signing of the deed by which the ministers renounced their livings, their manses and possibly even their congregations – effectively throwing themselves out of society. This renunciation was the act made by every minister, with his wife and their families, which established that each, by his own will and conscience, was making that sacrifice [**8**]. It was the basis of the break with the state – the need for the individual conscience to be free, within the Church. The idea of renunciation suggested an emphasis in the picture on each person, rather than on the crowd – a democratic idea. On the day after the signing on 23 May, Hill advertised a print from his painting, *The Signing of the Deed of Demission*, in ambitious terms. It was to contain:

> *Portraits from actual sittings, in as far as these can be obtained,*
> *of the most venerable fathers, and others of the more eminent and*
> *distinguished ministers and elders, as also of the members of the*
> *Deputation from the Presbyterian Church of Ireland – and of the*
> *representatives of various bodies of Evangelical Dissenters, who*
> *sympathise with and approve of the present movement of the*
> *Church – and of other personages who have taken or may yet take*
> *part in the eventful proceedings of the Assembly.*[6]

Two people observed Hill at work: David Brewster and Hugh Miller (1802–1856), who was the editor of the Free Church newspaper, *The Witness* [**10**]. Miller wrote an optimistic notice on the proposed painting, praising Hill as 'a master of character in its higher departments; … a gentleman of exquisite taste and fine genius'.[7] Brewster introduced Hill to Robert Adamson and wrote to Talbot:

> *I got hold of the Artist, shewed him the Calotype, & the immense advantage he might derive from it in getting likenesses of all the principal characters before they dispersed to their respective homes. He was at first incredulous, but went to Mr Adamson, and arranged with him the preliminaries for getting all the necessary Portraits. They have succeeded beyond their most sanguine expectations. Mr D.O. Hill, the Painter, is on the eve of entering into partnership with Mr Adamson and proposes to apply the Calotype to many other general purposes of a very popular kind, & especially to the execution of large pictures representing difft. bodies & classes of individuals.*
> *I think you will find that we have, in Scotland, found out the value of your invention not before yourself, but before those to whom you have given the privilege of using it.*[8]

The two men were astonished by the results they achieved with the calotype process, and entered into partnership to explore it further. This partnership largely defined the character of Adamson's studio work. Most of the world's professional studios were designed to take portraits for individual clients. Hill, like Talbot, thought of photography as a means of publication for a wider and more thoughtful audience.

Their first exhibition, of sketches for the Disruption picture and of an independent series of portraits of ministers, was opened on 12 July. In the same week, Hugh Miller published an enthusiastic account of the calotype process and of Hill and Adamson's work. He regarded photography as:

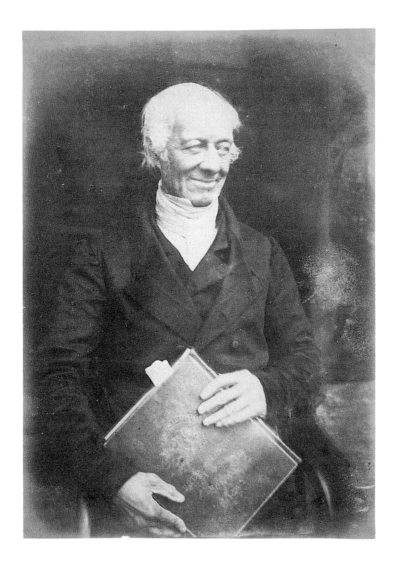

[8] Revd Hugh Mackay MacKenzie

Hugh MacKenzie of Tongue was a man for whom the decision to leave the church was especially painful and he was 'haunted by the denunciations of Scripture against the shepherds who leave their flocks'. But, by the time of the Disruption, he was clear in his conscience, calm and smiling. At the Disruption, he and his son, also a minister, were obliged to move from the manse to a derelict cottage, to enable them to stay in the parish. Sadly, within two years, he was attacked by fever and died.

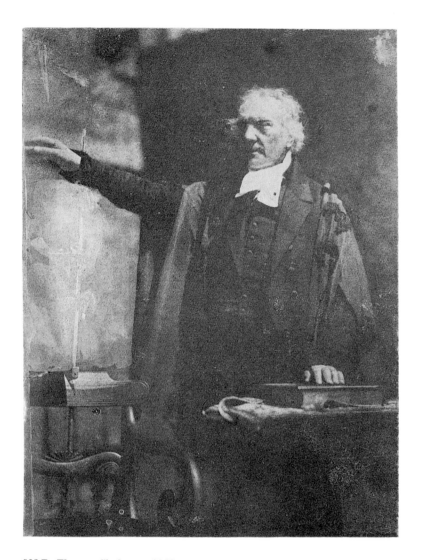

[9] Dr Thomas Chalmers, 1843

Hill's first idea for the Disruption picture was to focus on
Thomas Chalmers, the charismatic leader of the Free Church. It
was said of him: 'He was from the first a man of original genius,
one of those men, who nature has marked out as extraordinary
by faculty and character, and likely to be extraordinary in their
lives.' This study, with Chalmers's hand supported in a clamp,
indicates the dramatic manner of the evangelist's preaching.

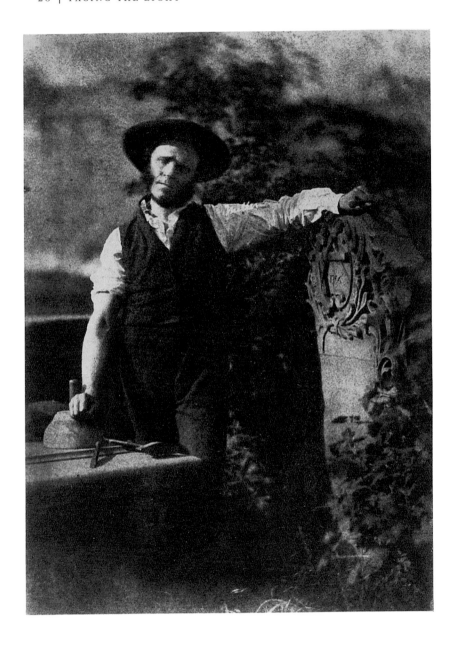

'A real invention, which bids fair to produce some of the greatest revolutions in the fine arts of which they have ever been the subject.'[9] Amongst other possibilities, Miller discussed the use of photography to capture groups, to determine perspective, and for book illustration. He was practically involved, posing for straightforward portraits for the painting, and for more distinctive photographs of himself as a stonemason. Miller's involvement in the calotype work is the first example of the practical enthusiasm expressed by a number of people – principally artists – who came to act as models and sometimes to organise photographs themselves. In the summer of 1843, George Harvey (1805–1876) asked for calotypes to be taken in Greyfriars Churchyard as studies for a painting [11 & 12], and in the autumn, Sir William Allan (1782–1850) arranged his own self-portrait [13].

In the autumn, Hill and Adamson attended the second Assembly of the Free Church in Glasgow to secure more portraits. They also exhibited their work in the Board of Manufactures' exhibition and were awarded a prize of ten pounds, 'for combining in the happiest possible manner artistical freedom of excellence with scientific precision of execution'.[10] By November, Brewster wrote to Talbot:

> I wish I could send you some of the fine Calotypes of ancient
> Churchyard Monuments as well as modern ones taken by Mr

[10] **Hugh Miller, 1843**

The new art of photography was fascinating to many people, and many of the subjects of the calotypes were interested in the process and the constructing of pictures, drawn in light. Hugh Miller, the geologist and writer posed for Hill and Adamson on several occasions and wrote one of the first critical accounts of the process. Earlier in his career, he had been a stonemason, as he appears in this calotype, which was taken in the Calton cemetery, just over the road from Rock House.

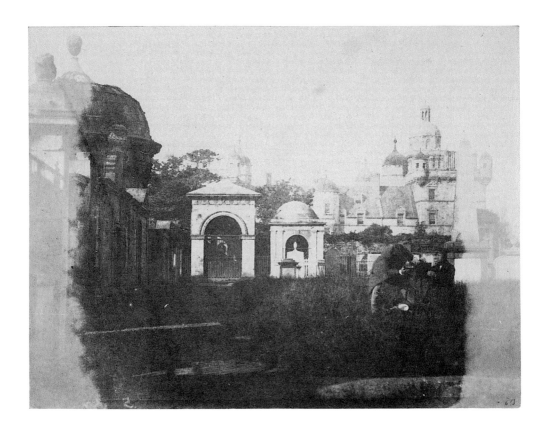

[11] Greyfriars Churchyard

Greyfriars Churchyard in Edinburgh was important to the Free Church as the place where the Presbyterian national covenant was signed in 1638. The churchyard was particularly rich in seventeenth-century carved tombs. The two figures, leaning over the camera, may be Hill and Adamson.

[12] Dennistoun Monument, Greyfriars Churchyard

This photograph is known as 'The Artist and the Grave-digger', and includes Hill and two of his nieces. Historic graveyards were places for the consideration of history and morality and the grave-digger had a second role as guide to the place.

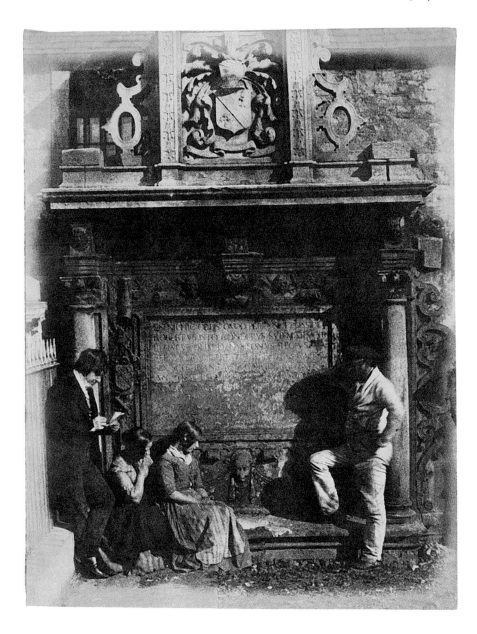

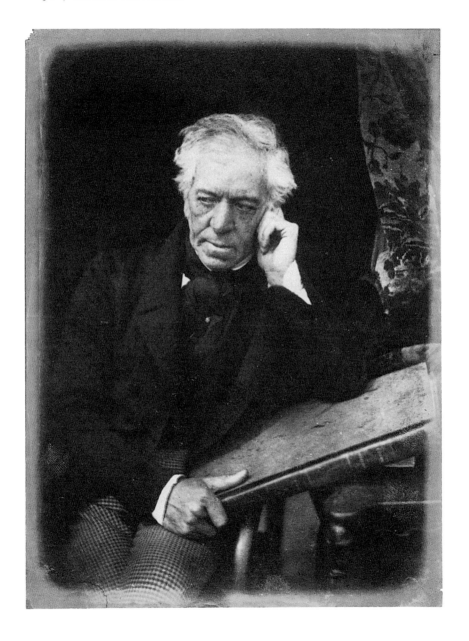

*Adamson, and also specimens of the fine groups of Picturesque
personages which Mr Hill and he have arranged and
photographed. Those of the Fishermen & women of Newhaven
are singularly excellent. They have been so inundated with work
that they have not been able to send me a Collection.*[11]

Photography required good light, preferably sunlight, and was a largely
seasonal business, but on 23 December 1843, Hill asked permission to take
a camera onto the roof of the Royal Institution, for himself, Adamson and
an assistant. The weather had been particularly mild – a pear tree in North
Castle Street had not only flowered, but also produced fruit and 'upwards
of a dozen small pears' were gathered in January.[12] However, the light may
have been inadequate as they made only a poor negative of the view along
Princes Street including the half-built Scott Monument. This was the first
of a series, charting the progress of the monument and the work of the
masons, up until its opening in 1845 [**14, 15 & 16**].

Hill and Adamson worked with at least one assistant, who was later
applauded as 'thrice worthy Miss Mann, that most skilful and zealous of
assistants', by the knowledgeable engineer, James Nasmyth (1808–1890).[13]

[13] Sir William Allan

In his youth, William Allan spent nine years in Russia painting
studies of life amongst Cossacks, Circassians and Tartars. When he
returned to Scotland, he became a friend of Sir Walter Scott and
turned to painting scenes of Scottish life and history. Allan was
president of the Royal Scottish Academy and in this capacity was
closely associated with Hill, who was the secretary. Allan died of a
tumour in the throat in 1850. At the time of the funeral, Hill
reported of Allan's Skye terrier, Dandy: 'This poor little doggie
when his master died went down stairs and could never after be
persuaded to take a particle of food – and on the morning of the
funeral gave the true pledge of heartbreak and sorrow by dying.'

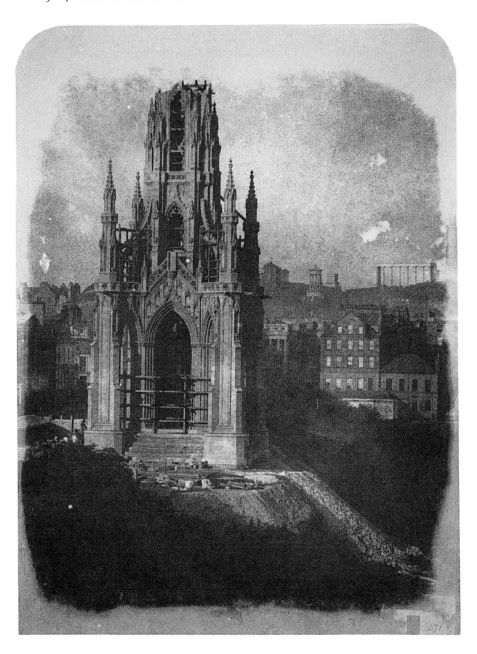

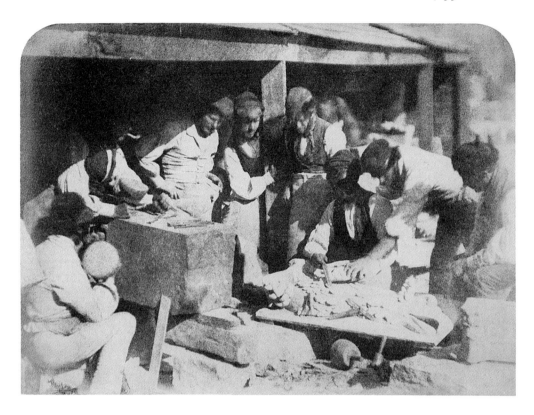

[14, 15 & 16] The Scott Monument

Work began on the Scott Monument in 1840. Hill and Adamson charted its progress from 1843 to 1845, climbing onto the roof of the Royal Institution (now the Royal Scottish Academy) with the camera. The committee responsible for the building had run out of money for the sculpture to decorate it, and fancy dress parties, called Waverley Balls, were staged to raise funds in 1843 and 1844. The calotype of the completed monument, taken in 1845, shows it without Sir John Steell's sculpture of Scott, as this was still being carved from marble imported from Carrara in Italy. The first block was so heavy that it sank the ship. The second arrived in Leith in November 1844, and it took twenty horses to drag it up the hill to Steell's studio, denting the streets as they passed. When the monument was complete, reactions varied. Charles Dickens was disappointed, Gladstone called it 'elaborate and very lofty', and John Ruskin called it 'a small vulgar Gothic steeple'.

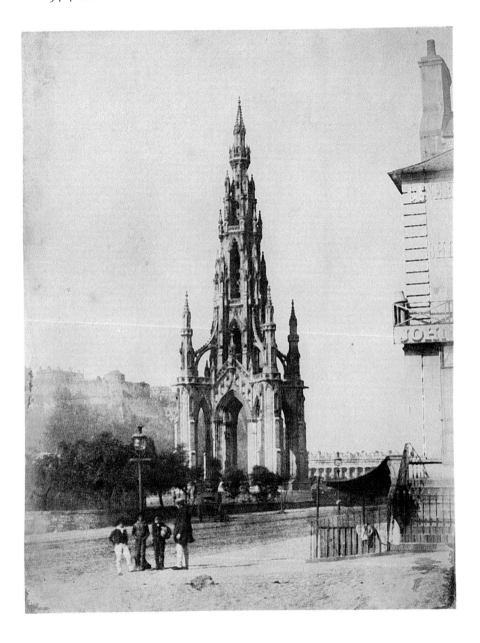

In August 1844, 'an assistant' found her or himself alone in the studio facing the demands of the King of Saxony, who, semi-incognito, was touring Britain with his entourage. David Brewster had recommended him to visit Robert Adamson, but had presumably forgotten to send a note of warning to Edinburgh that a king might drop by. The results, said the king's physician (himself an art critic), were not particularly successful, and he went on to philosophise about the failures of photography.[14]

In the spring of 1844, Hill moved in to Rock House to work more closely with Adamson. In August, they advertised six publications entitled *The Fishermen and Women of the Firth of Forth*, *Highland Character and Costume* [**17 & 18**], *The Architecture of Edinburgh and of Glasgow*, *Old Castles and Abbeys in Scotland* and *Portraits of distinguished Scotchmen*; 'the subjects selected and arranged by D.O. Hill and the chemical manipulations by Robert Adamson'. Hill later explained that these were to be '6 volumes or parts each containing about 20 or 25 subjects – each part 5 Guineas', which could be collected by subscribers to make a single large volume. He referred to it as, the '*first* book of English Calotype *pictures* for really Talbot's examples in his Pencil of Nature are not intended to be such'. The ambition of this is underlined by comparison with Talbot's series, *The Pencil of Nature*, which was issued in parts from June 1844. While Hill and Adamson's pictures would be priced at five shillings each in particular subject groups, Talbot's were erratically produced in groups varying from three to seven at a price of two shillings and sixpence.

At the same time, they ordered at least one new camera from the expert Edinburgh optician, Thomas Davidson (1798–1878), which could take photographs up to sixteen by thirteen inches in size, either using a lens or a mirror to focus the light. They also ordered and tried out an achromatic solar microscope with the idea of making enlargements. Davidson assisted them to take tests with small sections of wood, which they enlarged about forty times.[15] The big camera was designed to produce calotypes large

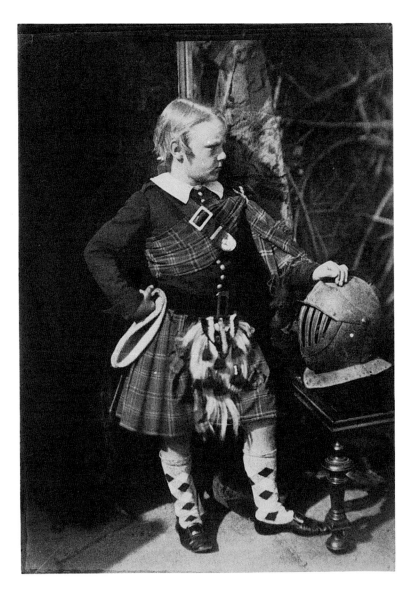

[17] **Jimmy Miller**

Jimmy Miller, also called by Hill 'The Young Savage', was the son of the
professor of surgery at the University of Edinburgh, James Miller. He is one of
the few children to appear in the Disruption picture. He is resting his hand on a
German tournament helmet, which belonged to Hill.

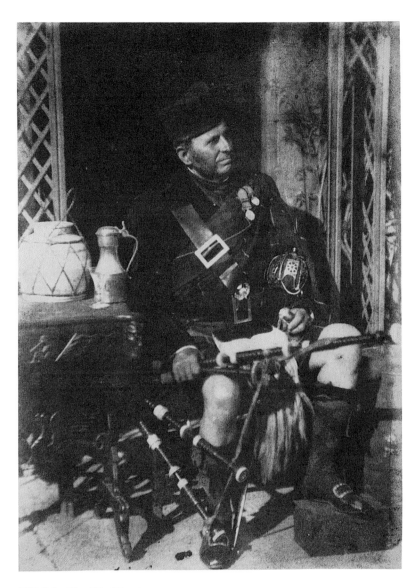

[18] John Ban MacKenzie

John Ban MacKenzie was piper to the Marquis of Breadalbane and won a gold medal from the Highland Society for his piping. He was described as 'The handsomest Highlander of his day, tall and of magnificent physique and upright in appearance as in character.'

enough to compete with the splendid engravings of the day, which could be framed and hung on the wall. They took the camera with them to Linlithgow, on the new railway line between Glasgow and Edinburgh. They charted the progress of the new Free Church Assembly Hall, and carried the camera out to Merchiston Castle School, to the south of Edinburgh, where they photographed the family of the Revd Thomas Chalmers [**19**], his brother, the headmaster of the school, and a few large groups of the schoolboys.

In September, Alexander Christie, one of the directors of the Trustees' Academy in Edinburgh, took a large group of the calotypes to Paris. They were presented at a session of the Académie des Sciences, apparently at the instigation of the painter, Ary Scheffer, who greatly admired them.[16]

At the end of September, Hill and Adamson travelled down to York to record the meeting of the British Association for the Advancement of Science. Talbot himself was there. They set up in the grounds of the museum and invited the visiting experts to sit for their portraits. This was not a happy occasion and the reaction to Hill and Adamson's work was partly hostile. This hostility probably stemmed from a general concern that Talbot's patent was blocking a number of new methods of photography described during the meeting. The calotypes that were taken were not as consistently good as usual, presumably because Adamson did not have ideal conditions to work in and also Hill did not work well in the face of hostile criticism. However, some of their results were good. Amongst the successful pictures was a study of the influential Marquis of Northampton (1790–1851), which Hill felt was 'singularly Rembrandtish' [**20**], and a calotype [**21**] of the coastguard and geologist, Charles Peach (1800–1886). He added: 'one Yorkites opinion consoles me – for William Etty saw in them revivals of Rembrandt, Titian and Spagnoletto'. Etty came to Edinburgh shortly afterwards with his brother, a sugar planter in Java whom he had not seen for thirty-one years. He was fêted by the members of the Royal

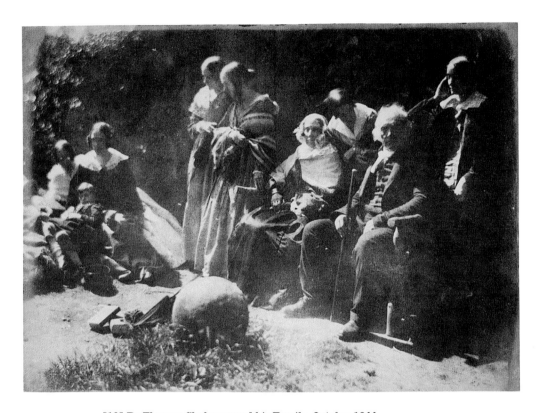

[19] Dr Thomas Chalmers and his Family, October 1844

This calotype was taken in the grounds of Merchiston Castle
School, where Thomas Chalmers's brother was headmaster. The
picture is composed in an astonishing abstraction of light, in which
the figures are only partly defined. When Dr Chalmers died in
1846, Dr John Brown wrote, in sorrow: 'It is no small loss to the
world, when one of its master spirits – one of its great lights – a
king among the nations – leaves it. A sun is extinguished; a great
attractive, regulating power is withdrawn.'

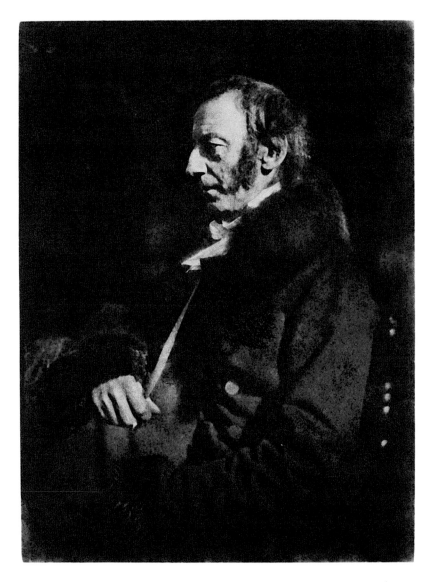

[20] **The Marquis of Northampton, 28 September 1844**

Lord Northampton was a man of importance in the worlds of science and art. Hill and Adamson calotyped him at the annual meeting of the British Association for the Advancement of Science in York. Hill wrote of the photograph that they had made 'a singularly Rembrandtish & very fine study'.

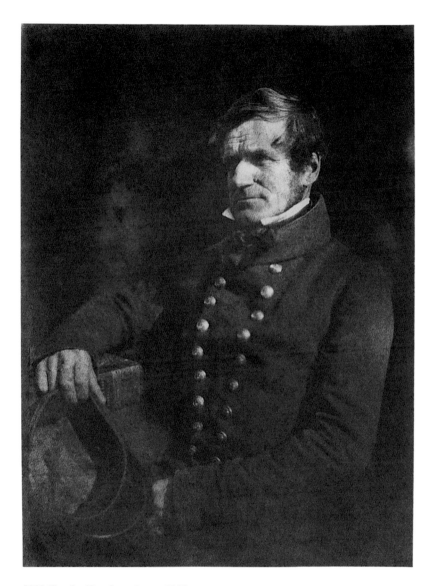

[21] Charles Peach, autumn 1844

Charles Peach was a coastguard in Fife, and a naturalist and
geologist friend of Hugh Miller. The calotype was probably taken
at the meeting of the British Association for the Advancement of
Science in York.

Scottish Academy and photographed by Hill and Adamson, despite the fact that he was without a change of clothing and was crumpled from travel [22].

In 1845, Hill's ally in London, the painter, David Roberts (1796–1864), reported that the calotypes he had shown to meetings of the Graphic Society and at the house of the Marquis of Northampton, had been greeted with critical acclaim. It looked as though they were about to break into the London market, and Hill wrote an enthusiastic letter proposing an album of English notables to celebrate this 'English invention' with a 'great and noble work'.[17]

Hill's combined excitement and anxiety about the calotype work was expressed in the next letter, which concluded:

I have sunk some hundreds of pounds and a huge cantle [part] *of my time in these Calotype freaks. I think the art may be nobly applied – much money could be made of it as a means of cheap likeness making – but this my soul loathes; and if I do not succeed in doing something by it worthy of being mentioned by Artists with honor – I will very likely soon have done with it.*[18]

[22] William Etty, October 1844

William Etty was a celebrated painter, born to pious Methodists of York. He was quoted as saying that 'as all human beauty was concentrated in woman, he would dedicate himself to paint her'. He chose subjects from the Bible and the great poets that required prominent female nudes. In mid-October, Etty arrived unexpectedly in Edinburgh with his brother, and his niece. He wanted to show them three of his major paintings, which had been bought by the Royal Scottish Academy: *The Combat, Benaiah Slaying Two Lion-like Men of Moab,* and *Judith.* The academy hurriedly organised a reception for him and Hill took advantage of the occasion to invite the Ettys to Rock House to be photographed.

In the following year, Hill's friends, Elizabeth Rigby (1809–1893) and Dr John Brown (1810–1882), wrote glowing reviews of the calotypes and recommended Talbot to invite Hill and Adamson to work in England. Presumably because Talbot had sold the calotype patent rights to another photographer, Antoine Claudet (1797–1867) who was based in London, these plans came to nothing. Hill then turned his attention to the idea of marketing handsome volumes of a hundred calotypes, as a 'sort of *Liber Studiorum*', meaning that they would act as an exploration of aesthetic possibilities in photography, comparable to the example of Turner's series of landscape engravings.

In 1846, Hill returned to the original idea which prompted the partnership, the production of photographic studies for large paintings. Hill and Adamson took calotypes of the 92nd Gordon Highlanders, garrisoned in Edinburgh Castle [**24 & 25**], and an ambitious series of photographs from the castle, looking at the city through an arc of about 180 degrees, to make a panorama. In 1847, Hill produced his picture *Edinburgh Old and New*, based on the calotypes. It is a painting in which his concern for aerial perspective, the sense of atmosphere rather than the structures of the architecture, and a feel for human and historic time, show his sophisticated examination of photography [**23**].

By this time, Hill should have completed the Disruption picture. However, he was still advertising for sitters in May, and had doubled the size of the painting. But halfway through the year, the studio seems to have suddenly slowed down; the bulk of their calotypes, numbering more than 3,000, had been taken before this date. This may be the point when Robert Adamson first fell seriously ill. His illness certainly affected production in 1847, and in August, Hill wrote: 'Adamson has been so poorly for many months that our calotype operations have gone on but slowly.'[19]

One group of photographs which may have been taken in 1847, are calotypes taken at Bonaly Tower [**26**], home of the noted Lord Cockburn,

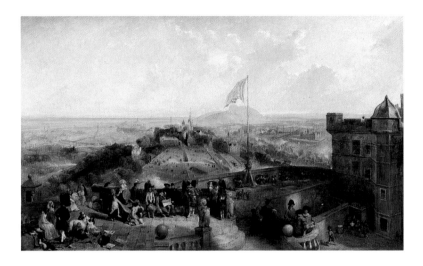

[23] D. O. Hill 'Edinburgh Old and New', 1847

Hill's painting of Edinburgh from the castle was designed to show a city built on the volcanic spine of the Royal Mile and expressing some of the energy of its volcanic history, as well as the immediate evidence of smoke from the chimneys and wind-blown flags. It connects history and the present, through the highlighting of the monuments and the numerous figures spread throughout the picture.

who worked with Hill as legal adviser to the Royal Scottish Academy. Bonaly Tower was a neo-baronial building, echoing the enthusiasms of Sir Walter Scott, where Cockburn entertained his friends to handsome picnics. The photographs became part of the entertainment and they planned a 'Bonaly Book'. In October 1847, Cockburn wrote to Hill thanking him for the gift of calotypes:

> *The true value of the donations, in my sight, consists in the kindness that sends them, & in the reciprocity of this feeling, I am conscious that I am not unworthy of your favour – for I have a very strong & sincere esteem for you … Weather & Adamsons health have been*

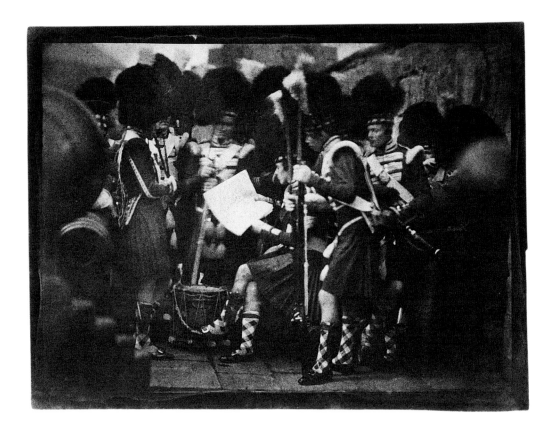

[24] **Reading the Orders of the Day, August 1846**

[25] **92nd Gordon Highlanders, August 1846**

The 92nd Gordon Highlanders were stationed at
Edinburgh Castle in 1846, having just returned from
the West Indies, when Hill was making studies for his
painting, *Edinburgh Old and New*. Hill took the
opportunity to take a series of pictures of the men,
where the blur of the image gives a sense of life to
the calotypes.

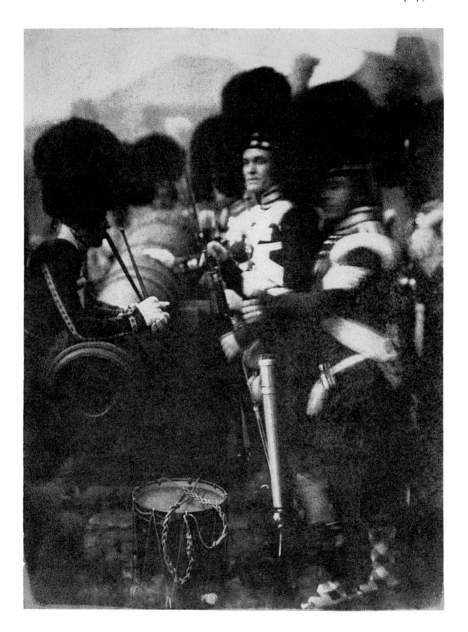

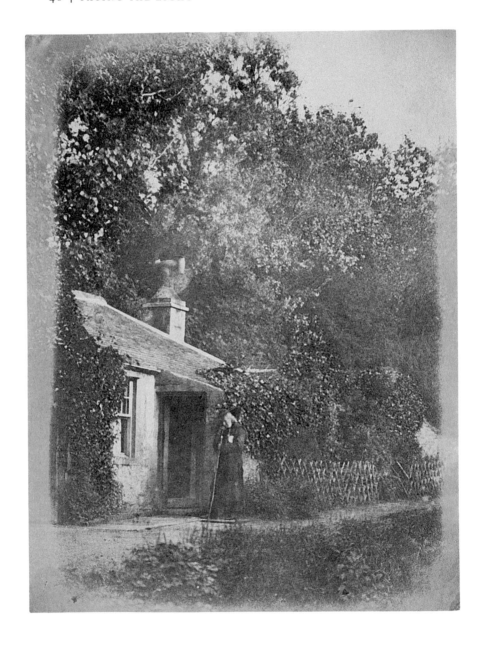

adverse to the completion of the Bonaly Book, but Hope, which
fortunately for mortals never dies – hints about 1848.[20]

Amongst the last photographs taken, in October 1847, may have been the
tree studies in Colinton Wood and the calotypes of Colinton manse and
weir [**27 & 28**]. There they saw what Robert Louis Stevenson, visiting his
grandfather in the manse, described from his childhood memory:

> *The river is there dammed back for the service of the flour-mill*
> *just below, so that it lies deep and darkling, and the sand slopes*
> *into brown obscurity with a glint of gold; and it has but newly*
> *been recruited by the borrowings of the snuff-mill just above, and*
> *these, tumbling merrily in, shake the pool to its black heart, fill it*
> *with drowsy eddies, and set the curded froth of many other mills*
> *solemnly steering to and fro upon the surface.*[21]

Sadly, at the end of 1847, Robert Adamson's health finally broke, and he
retreated to St Andrews. On 14 January 1848, he died. Hill wrote:

> *I have today assisted in consigning to the cold earth all that was*
> *earthly of my amiable true & affectionate Robert Adamson. He*
> *died in the full hope of a blessed resurrection. His truehearted*
> *family are mourning sadly especially his brother the Doctor –*
> *who has watched him as a child during his long illness – I have*
> *seldom seen such a deep & manly sorrow. Poor Adamson has not*
> *left his like in his art of which he was so modest.*[22]

[26] The Lodge at Bonaly Tower

Hill and Adamson may have taken a camera out to Bonaly on
several occasions. The Scottish judge, Lord Cockburn, had built his
neo-Baronial tower in the country (inspired by Sir Walter Scott), and
regularly held picnics for his friends. On this occasion, the sculptor,
John Henning, had dressed up as Edie Ochiltree, the beggar from
Scott's novel, *The Antiquary*, and is seen at the lodge door.

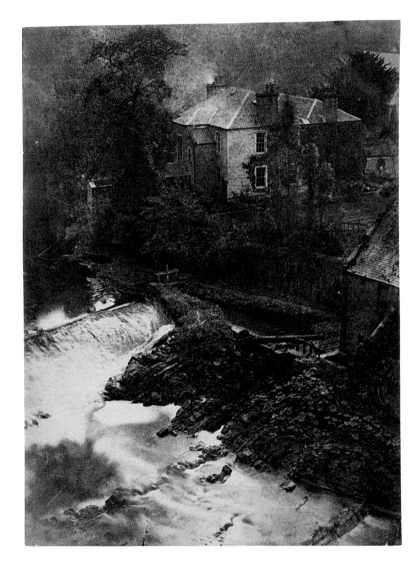

[27] Colinton Manse and Weir

Colinton manse was currently the home of the Revd Lewis Balfour, his wife and daughters, one of whom would marry and become the mother of Robert Louis Stevenson. The manse stood on the edge of the Water of Leith, a vigorous stream driving both a snuff mill and a flour mill in this one short stretch.

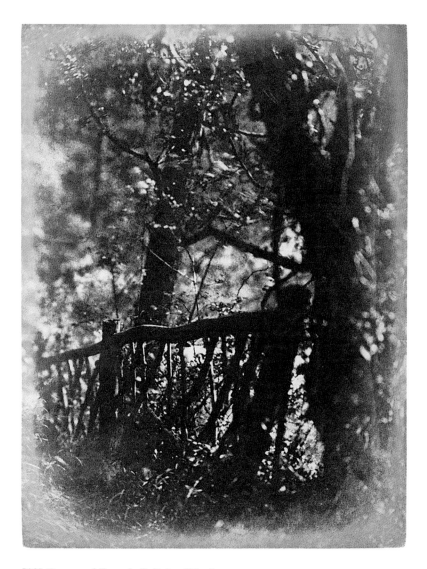

[28] Fence and Trees in Colinton Wood

Hill received permission to take photographs in Lord Dunfermline's
grounds at Colinton late in 1847. This picturesque study of a simple fence
and trees may be one of the last photographs Hill and Adamson took,
before ill health forced Robert to retreat to St Andrews.

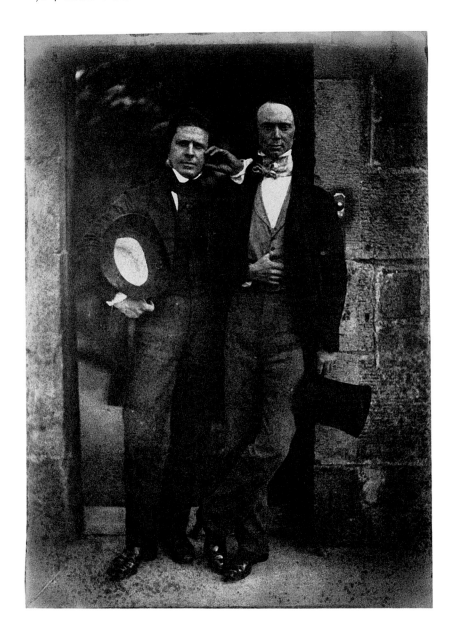

The Inventive Partnership

The partnership between Hill and Adamson is remarkable in the history of art. It represents an active interchange of talent and interest between the two leading figures, and was the focus of intelligent discussion for other highly capable and curious people – including John Adamson, Miss Mann, Thomas Davidson, Hugh Miller, Elizabeth Rigby and an impressive roll-call of artists [**29, 30 & 31**].

Hill himself expressed the distinction between the calotype and the daguerreotype in these terms:

> *The rough surface & unequal texture throughout of the paper is*
> *the main cause of the calotype failing in details before the process*
> *[or 'precision'] of Daguerrotypy – & this is the very life of it.*
> *They look like the imperfect work of a man – and not the much*
> *diminished perfect work of god.*[23]

[29] D. O. Hill and William Borthwick Johnstone

This photograph may have been taken at Newhaven, rather than Rock House, and could be an exercise in how to form a group, using the doorway as a prop. William Borthwick Johnstone, known for good reason as 'Neckie Johnstone', was a fellow artist and later the first director of the National Gallery of Scotland.

He added at the end of this same letter: 'I think you will find that the calotypes like fine pictures, will be always giving out new lights, and thus by showing themselves gentlemen of varied qualifications and acquirements, contriving to be agreeable companions in a house.'

Hill's feeling for the calotypes is a little oddly expressed, but he regarded them as having something that gave them a life of their own and an ability to be 'fine art'. He appreciated the difficulties, rather than the supposed ease of photography; these were both the chemical and technical difficulties, controlled by Adamson and Miss Mann, and the unexpectedly difficult organisation of the subject to achieve an appearance of nature, which was Hill's province.

The partnership seems to have been continually inventive and experimental. Hill wrote in 1845:

I believe from all I have seen that Robert Adamson is the most successful manipulator the art has yet seen, and his steady industry and knowledge of chemistry, is such that both from him and his brother much new improvements may yet be expected.[24]

[30] Horatio McCulloch

Horatio McCulloch was born on the night that Glasgow was celebrating Trafalgar Day, hence his Christian name. He began his working life as a house painter in Glasgow, and then attended classes with the landscape artist, John Knox. In the 1840s, the standing of Hill and McCulloch as landscape painters was probably equal, but McCulloch's later career established him as the better painter and as a master of the grand romantic Highland landscape. Hill, who organised the exhibitions at the Royal Scottish Academy, wrote in 1846: 'Macculloch has sent us a noble highland landscape – by far his best work – really most beautiful – it is sold for 200 guineas. If he goes on painting in this vein his name will become famous among the nations.'

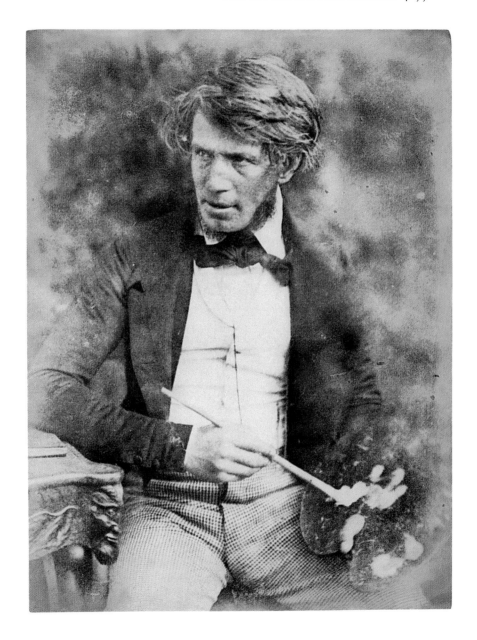

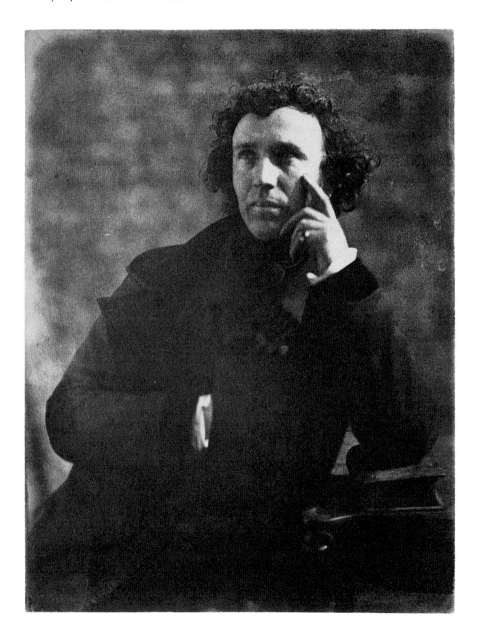

Robert and John did not publish their improvements and Hill respected their professional secrecy: 'I know not the process, though it is done under my nose continually, and I believe I never will.'

Thomas Davidson, himself an expert instrument maker, wrote that Hill and Adamson were proposing to patent some improvement to the solar microscope. The large camera, in itself, was remarkably ambitious. Hill sent a few of the photographs to an exhibition in 1856, writing that they were:

> ... of a size 16 inches by 14 & under, when there were no other
> calotypes in existence a half of the same size. Considering the size
> — the period, & that they were from an Edinburgh made camera
> — they may also possess an interest to a Scottish photographic
> Society as enabling them to claim for Scotland an honorable
> priority in certain phases of the art.[25]

This camera had a greater interest. Davidson designed it to be adaptable, to use a mirror as well as a lens to take photographs.[26] Davidson's mirror had twenty-four inches in diameter and a thirty inch focus (F 1.25), and in comparison with the possible best wide lenses of the time, could have shortened

[31] Sir John Steell

The sculptor, John Steell, was born in Aberdeen and trained in Edinburgh and Rome. Urged to go to London by the sculptor, Sir Francis Chantrey, he declined in order to devote all his energies to the improvement of art in Scotland. Steell's reputation was assured following his modelling of a bust from life of Queen Victoria in 1838 and his appointment as the first ever 'Sculptor in Ordinary to HM Queen for Scotland'. At the time this calotype was taken Steell was working on his sculpture of Sir Walter Scott, with his dog, Maida, for the Scott Monument, making him the first Scot to execute a monumental figure of national importance. The calotype is impressive for its simplification and the drama of the composition — only his head and his left hand are clearly defined.

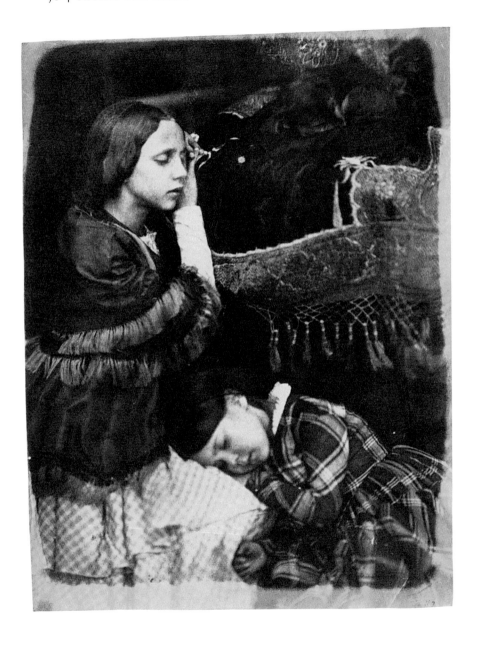

exposure times by a factor of ten. This radically important move indicates that Hill and Adamson were attempting to cut down exposures to seconds rather than minutes. Given that they photographed small children, street urchins and schoolboys, and even a puppy, it is probable that they succeeded [**32**].

The inventiveness of the partnership went beyond the camera. As a landscape painter, Hill was especially interested in the effects of different weather and light. In the calotypes we are seeing the effect of the light on the subject as much as a sense of its solid reality. Hill and Adamson were ready to point the camera obliquely or directly into the sun to see how the light would flare and alter shapes [**34**]; they photographed the reflections and the paths of the light. They devised ways of bouncing the light from different surfaces to soften and spread its impact, took pictures both in the hard glare of angled light and altogether away from direct light where it was simply diffused. They looked at shadows – the strong shadow cast by the central figure animates the whole composition of the Fishergate photograph [**39**]; the shadow of Elizabeth Johnstone Hall's cap, cast across her cheek, gives delicacy to the picture [**58**].

Hill entered into partnership with Robert Adamson on the wave of the astonishing discovery that this apparently mechanical art was capable both of the imperfections and the life of fine art. Like earlier art forms, it had a positive character and it could be manipulated. Many people, including David Brewster, thought the camera would be a mechanical tool, over-

[**32**] **Sophia Finlay and Harriet Farnie**

This is one of four calotypes of girls with Hill's dog, Brownie. The girls are pretending to sleep, but presumably the dog, curled up on the chair, has been raced up Calton Hill until it collapsed in exhaustion. Hill later called the picture 'The Sleepers' and added 'Brownie, my stolen and lamented terrier pup'.

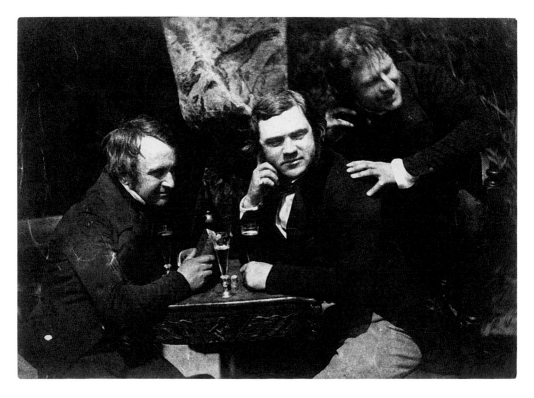

[33] James Ballantyne, Dr George Bell, and D. O. Hill,
'Edinburgh Ale'

James Ballantyne was a writer and stained-glass artist.
Dr George Bell was one of the commissioners of the Poor
Law. According to a contemporary account of the early
part of the nineteenth century, Edinburgh ale was 'a
potent fluid, which almost glued the lips of the drinker
together'.

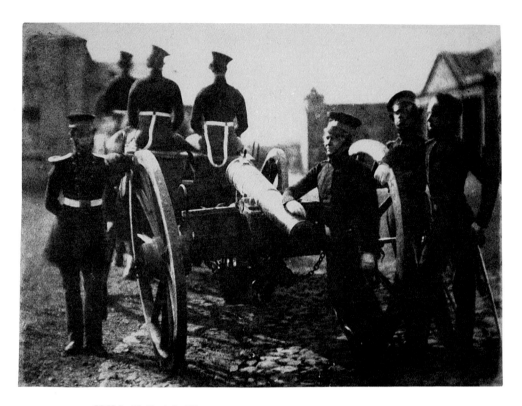

[34] Leith Fort Artillery

This photograph, taken at Leith Fort, is of particular
interest for its slanting use of light. The camera is nearly
pointing into the sun.

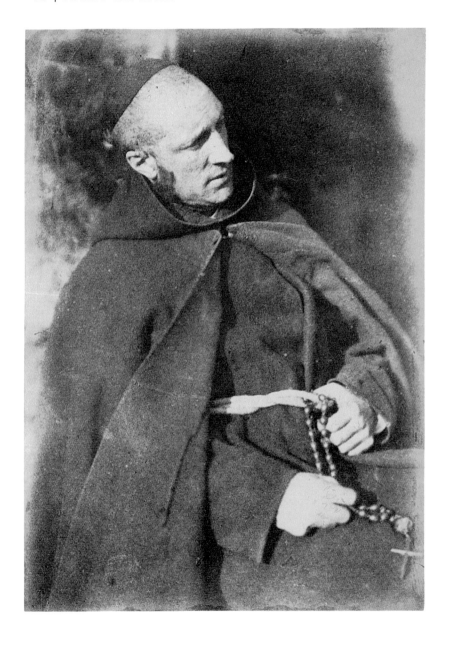

riding the personal element of the draughtsman and permitting nature to draw itself. Hill and Adamson demonstrated that it had an opposite and contrary character; that it had the potential for fine art.

The skill involved in producing calotypes was not simply technical. D.O. Hill had a particular sociability, largely untapped in his painting, that played a crucial part in his photography [33]. A friend, Dr John Brown, described him in these terms, in 1846:

> He has humour, which implies, we have always thought, not
> merely character in its owner, but a power of seeing into the
> character of others; and he has that thorough human-heartedness
> and love of his kind, that makes him lay out his affections on
> them wherever he sees them.[27]

It is remarked of portrait painters that they will often paint their sitters in their own image. A portraitist of strong or anti-social character, impatient or uncaring, will make his sitters defensive and they will mirror his lack of engagement. Painters or photographers need to respond to the way people are, to conjure up a likeness for a picture. Coldness or aggression invites a hard and simple response; warmth invites the possibility of greater

[35] William Leighton Leitch

W. L. Leitch was born in Glasgow, the son of a manufacturer who sent him first to a private school, then to the school of the Highland Society, and then to a lawyer's office. But an early love of art had been fostered by meetings with the artists, Horatio McCulloch, and Daniel Macnee. He abandoned the lawyer's office and became a landscape painter. His work was admired by Queen Victoria and he taught her drawing for almost twenty years. In 1864, after many visits to Balmoral, Osborne House and Windsor Castle, he was granted a royal annuity and at the studio sale after his death, the queen acquired many works by my 'kind old drawing master'. In this calotype, he has shaved his hair off to act as a monk for the camera.

eccentricity or sophistication. It is the second condition in which people re-
veal themselves, when a painting or a photograph may become a portrait.
The great American photographer, Paul Strand, defined this:

> *A portrait in the sense that a person completely unknown to the*
> *world at large, not connected with those who will see the painting*
> *or photograph has a living quality… there is no necessity to be*
> *acquainted with the subject in order to have from the portrait*
> *complete esthetic and human satisfaction. Of course Hill did this*
> *consummately.*[28]

David Brewster saw and disliked this variable effect in photography. He
wrote to Talbot:

> *I have been very much struck with the* different calotypes *of the*
> same person. *In many of them, where the sitter was steady, –*
> *the family likeness is scarcely preserved. Does this arise from the*
> *camera? I have seen among Mr Adamson's calotypes pictures of*
> *men & women in one of which the sitter was decidedly* good
> looking *and in the other* hideous. *There is something yet to be*
> *done in reference to this point.*[29]

Brewster considered that such variation was a failing of the technology.
Hill saw this same effect and was enchanted. It meant that the human and
social element involved in the taking of a photograph was as important as
the technical – the subjects needed to be brought out by sympathetic
warmth. When we look at the calotype portraits, we are looking not just
with Hill's eyes, but at a social situation he has created; we are introduced
into his company.

———————

[36] **Mr Lane and Mr Peddie as 'Afghans' or 'Circassians'**

It is not known whether these two men were genuine travellers
or simply participants in the highly popular fancy dress parties of
the day.

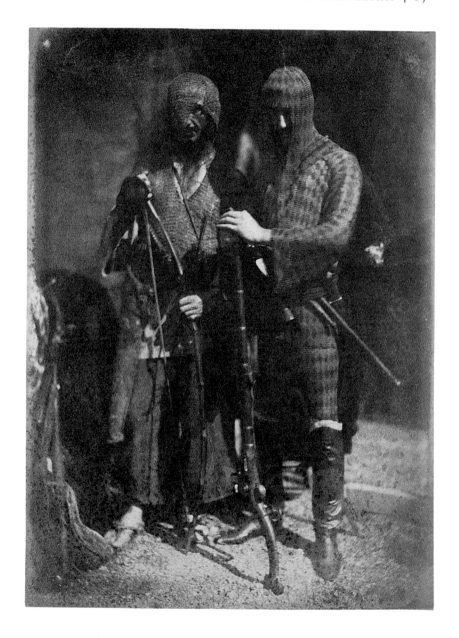

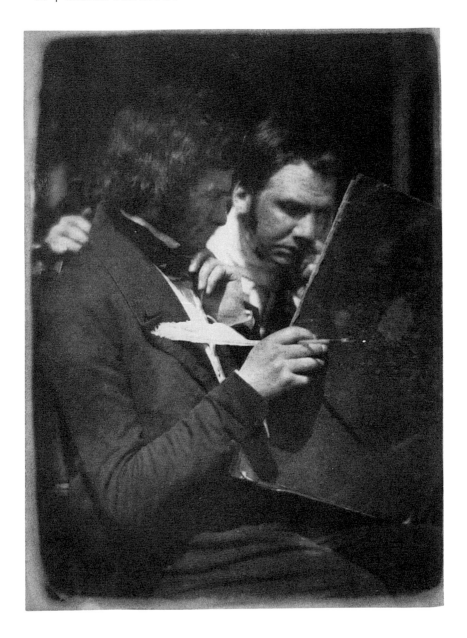

With the camera, Hill was able to assemble and arrange groups, not just of the professional artists, who were used to acting as models [**35 & 36**], but of real people in convincing situations, like the journalists, George Troup and William Gibson apparently engaged in intense discussion [**37**] or the two young girls, Ellen and Agnes Milne [**40**]. Calotypes, like the ones taken in Newhaven of obstreperous small boys, are astonishing [**38**]. Groups were not easy to achieve – the boys needed to be persuaded of the seriousness of the exercise and to stay still while Hill organised them into position; the group needed to be comfortably and convincingly placed, and the composition as a whole made satisfactory. The lines and shapes drawn by the sun, with the planes of the boat and the bonnets, are balanced by the humanity of the boys; their faces, hands and small, bare feet. The calotype process was comparatively coarse and this, as Hill said, was 'the very life of it', but the arrangement of people, in relation to the light, and the understanding and manipulation of the effects was a remarkably subtle business.

[**37**] **George Troup and William Gibson**

Troup and Gibson were newspaper editors. Both edited *The Banner of Ulster*, and Troup subsequently acted as editor of the *Aberdeen Banner* and *The Witness*. The calotype was a study for the Disruption painting, and is a good example of the use of strong light to make a successful composition.

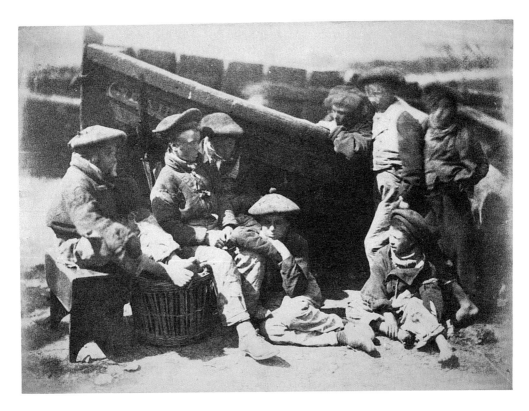

[38] Newhaven Boys

It is a tribute to Hill's skill that he was able to organise this group of small boys into sitting still, with the exception of the small blurred figure inside the boat. Not only did Hill have to arrange them in relation to each other and the boat but he also had to hold their attention for the long seconds of the camera's exposure time.

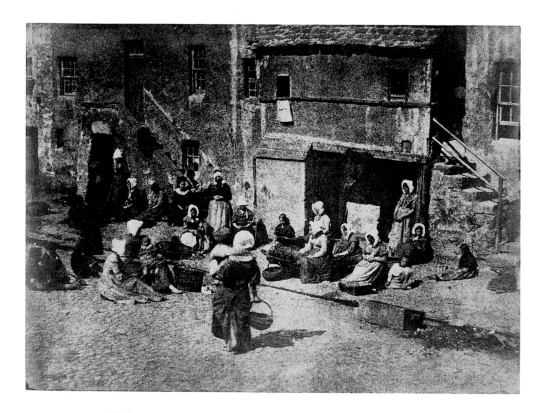

[39] Fishergate, North Street, St Andrews

Hill and Adamson took a camera across the river to St Andrews
to take pictures of the harbour and the Fishergate. The width of
North Street enabled them to take a large and spread-out group of
the fishwives and children, working outside their own houses. The
camera would have been perched on the ledge of one of the stairs
opposite, giving a high viewpoint. The organisation of the
composition is impressive, with the individual figures all distinct,
and is animated by the central figure, who is apparently striding
across the street with a child on her arm.

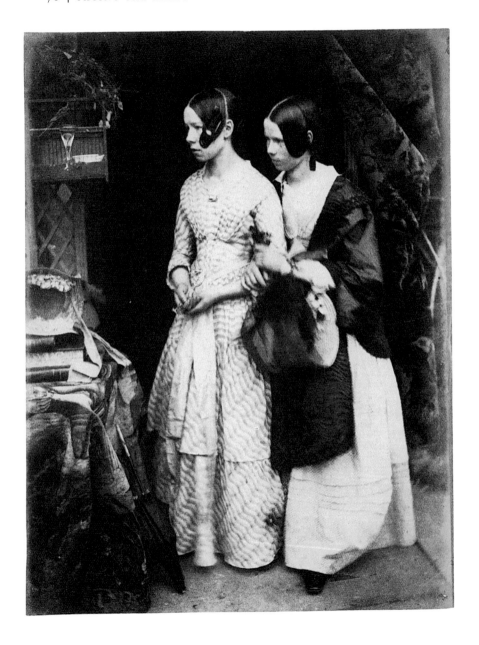

The People

Lord Cockburn had written of the period at the beginning of the century when the political dominance of the Tories was so powerful, that even friendships could not survive political difference:

> *Very dear friendships were in many instances broken …*
> *This incompatibility of public difference with private cordiality is*
> *the most painful recollections that I have of those days, and the*
> *most striking evidence of their hardness.*[30]

The individual brilliance, which Cockburn describes at this time, suffered from the handicap of isolation. It is a useful comment on the 1840s, that Hill's choice of subjects ranged over the political, religious and intellectual spectrum. He maintained friendships with people of opposite character and beliefs, and had an equally amiable relationship with strong individuals; men, women and children. He was a sociable and gracious man. After his death, his friend, James Nasmyth, wrote of him:

[40] Ellen and Agnes Milne

The image of girls with a caged bird, young and ready for flight, is a convention often used in the arts of the day. But their individual youthfulness gives a real charm to the group.

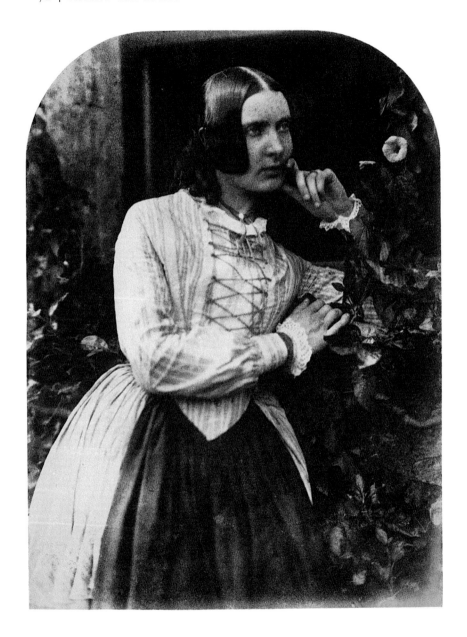

His name calls up many recollections of happy hours spent
in his company. His lively sense of humour combined with a
romantic and poetic constitution of mind, and his fine sense of the
beautiful in Nature and art, together with his kindly and genial
feeling, made him, all in all, a most agreeable friend and
companion. Altogether, he was a delightful companion and a
staunch friend, and his death made a sad blank in the artistic
society of Edinburgh.[31]

This sympathetic sociability makes the calotype portraits remarkable for
their direct communication. The people look as though they belong in our
own time, and they are remarkably interesting: practical people, witty peo-
ple, serious, sensitive, sometimes bloody-minded, sometimes kind. Their
history is worth discovering and is open to us. The vastly increased number
of books and articles published in Britain in the early nineteenth century
meant that an unprecedented number and range of people were writing for
publication. Moreover, with the introduction of the penny post in the 1840s,

[41] Patricia Morris

Patricia Morris was Hill's niece. She died in 1852 after an operation.
Hill described her pain and courage: 'Her sufferings were some-
thing awful to hear of … She could not have lived a week under
them. But she was ready & eager for the Doctors. On the Tuesday
she ordered in the table on which she was to be disposed – when
under the knife – and when the awful hour of twelve came – she
the only composed person in the house asked for her watch which
the Nurse had kindly removed from the bed curtain where it
generally hung, and the good soul returned it having put it back ¼.
Patricia said it is twelve – I know by the shadow on the floor – the
Doctors will soon be here – she was told they had arrived. She said
she was ready – and resigning her husbands hand which she had a
long time held – she told him to go away.'

people wrote many more leters and could afford to be more conversational – in Britain the number of letters carried rose to 329 million a year. This means that people can speak to us as never before.[32]

The portraits are naturally dominated by the Free Churchmen. In 1846, Elizabeth Rigby rudely remarked that 'the fat martyrs of the Free kirk' were still their favourite subjects, but she was speaking from a Tory perspective and as a supporter of the established church. The success of the Free Church was dependent on a Presbyterian idea of individual responsibility within the congregations, but it was also reflected by the international reaction. The assemblies drew people from all over the world; Europeans, Indians, Canadians and Americans. The Revd Dr Henri Merle D'Aubigné (1794–1872) from Geneva wrote of Tanfield Hall:

> *Under its bare rafters and rude beams there was assembled an enthusiastic auditory, filling the vast area. A Scottish assembly is no gathering of cold impassive listeners, as those in Switzerland and the Continent too often are; it is a living body of extreme sensibility, ready to respond to every touch. These multitudes feel an interest in the discussions affecting the cause of God, and the religious interests of mankind, more keen than the world does in political debates. Neither in the Houses of*

[42] Mary Duncan

Mary Duncan and her husband, Revd Henry Duncan, left one of the most beautiful manses and gardens in Scotland at Ruthwell. Rendered homeless, they found refuge eventually in a depressing cottage between a main road and a rubbish-filled quarry. Mary spoke with pleasure of this as 'a green field, with its little plots of wild roses and honeysuckle', and within three years they had planted the quarry with trees and transformed 'the whole huge deformity into beauty'.

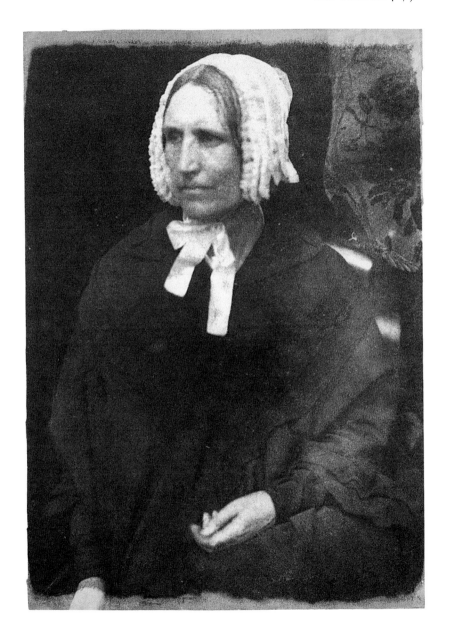

Parliament in London, nor in the Palais Bourbon in Paris, is to
be seen anything like what is witnessed in Edinburgh.[33]

The leading figure, amongst the equals of the Free Church, was the Revd
Dr Thomas Chalmers (1780–1847). A writer of the day, Mrs Oliphant,
commented:

The Evangelical party possessed at the same time the highest
intellect of the Church, and the greatest gifts. Such an orator as
Chalmers, a man entirely after its own heart, embodying at
once the enthusiasm and the practical character of its genius,
patriotic above all things, forming all his schemes and
expending all his powers for Scotland, was such a leader as
few could resist.[34]

Soon after the Disruption, Chalmers concentrated his energies once again
on a poor parish, the West Port in Edinburgh, exercising practical Christi-
anity for the benefit of the poor, who were 'living in dirt and dying in dark-
ness'. 'I have got now the desire of my heart', he wrote at the end of his life,
with a poverty-stricken community stabilised, the church filled with people
and all the children in the parish at school. A hundred thousand people
attended the funeral of this great man, and one account of his life compared
his death to the setting of the sun: 'It is no small loss to the world, when one
of its master spirits – one of its great lights – a king among the nations –
leaves it. A sun is extinguished; a great attractive, regulating power is with-
drawn.'[35] This idea of the sun and Chalmers as a man of light is to be seen
in the group photograph where the sun strikes the scene with such uncom-
promising force [**19**].

The Revd Dr Thomas Guthrie (1803–1873) referred to the Free
Churchmen as 'merry martyrs', and the recognition inherent in this, that
religion encompassed eccentricity, as well as the solemnity of moral virtue,
was a matter of very great importance. Guthrie wrote of the necessity of
considering different characters for heroism:

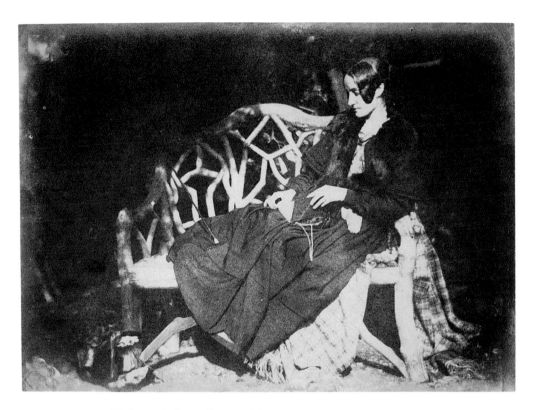

[43] Anne Chalmers Hanna, 1844

Mrs Hanna was the eldest of Thomas Chalmers's six
daughters. She had a quirky independence of mind, and
despite her Presbyterian background was ready to enjoy
Catholic ritual – shocking her own daughter greatly.

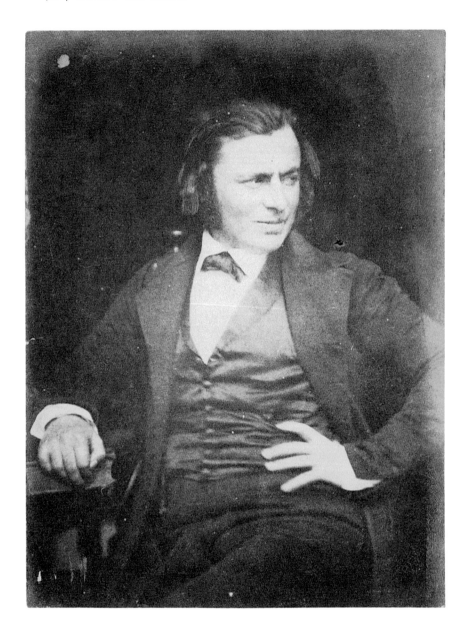

*Christians have individual peculiarities which, as much as their
faces, distinguish them from each other; and this is rather a
beauty than a blemish – a charm rather than a fault … It is a
power, an element of the highest utility in the Church. Hence the
mistake of those who would have all Christians modelled on their
own pattern, as, for example, of some modest, retiring, gentle
spirits, who cannot appreciate the worth and usefulness of those
whom God has cast in a rough mould and made of stern stuff.*[36]

We are apt to think of heroism as an extraordinary event in war, or similarly
exaggerated adventures abroad. But heroism was also a fact of everyday
life. The women of the Free Church faced the distress of the Disruption
with the same courage and practicality as the men. Thomas Guthrie spoke
of the importance of the manse garden to the woman of one particular
family, who, in seceding from the established church, were obliged to aban-
don the manse:

*They had had many trials: there had been cradles and coffins in
that home. There was not a flower, or a shrub, or a tree, but was
dear to them: some of them were planted by the hands of those
who were in their graves. That woman's heart was like to break.*[37]

[44] Henry Vincent

While the Free Church was rousing support for its search for
independence from the state, other reformers were looking for
political advantage. One of the leading figures in the Chartist
movement, seeking universal suffrage, was Henry Vincent, who
was imprisoned for inciting a riot, despite his comparatively
peaceful approach. He stood for parliament on a number of
occasions, and is likely to have been calotyped in 1844, when he
contested the seat of Kilmarnock. Although never elected, he was
an active campaigner for reform in politics and education.

Mary Duncan (d.1877) and her husband, Revd Henry Duncan (1774–1846), left one of the most beautiful manses and gardens in Scotland at Ruthwell [**42**]. Rendered homeless they found refuge eventually in a gloomy cottage between a main road and a rubbish-filled quarry. She spoke with pleasure of this as 'a green field, with its little plots of wild roses and honeysuckle', and within three years they had planted the quarry with trees and transformed 'the whole huge deformity into beauty'.[38]

Such heroism was partly driven by the difference in historical circumstances; death was a constant and appalling presence. Fatal diseases, like typhoid and cholera were endemic; women regularly died in childbirth and infant mortality was high; medical innocence had only been partly dispersed, and the treatments could kill as readily as the sickness.

Hill's niece, Patricia Morris, who is pictured in a calotype before her marriage to Mr Orr [**41**], was operated on by Professor John Syme in 1852. She benefited from the discovery of chloroform as an anaesthetic, which helped to reduce the shock but died soon after because the operation was conducted in her own bedroom. Surgeons did not yet understand the importance of antiseptic conditions. Surgery and the last phases of fatal illness generally took place at home rather than in hospital, with the family often undertaking the nursing. One of the women who went to the Crimea to nurse the sick and wounded soldiers, remarked mildly afterwards: 'I did not feel … that we were doing anything better or more praiseworthy than

[**45**] **Mrs Anne Rigby**

Mrs Rigby had an elegant sense of dress, admired by her daughter, Elizabeth, who held her up as a model of old age: 'Think of the moral charm exercised by such a face and figure over the circle where it belongs – the hallowing influence of one who, having performed all her active part in this world, now takes a passive, but a nobler one than any, and shows us *how to grow old*.'

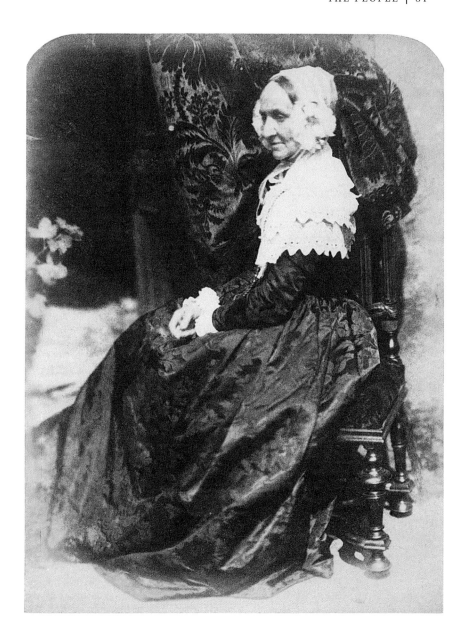

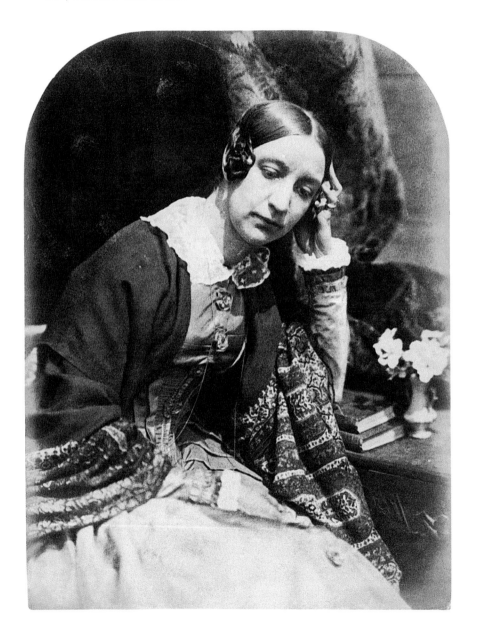

is done in a quiet, unostentatious way at home every day'.[39] Hill was one who saw and acknowledged this ordinary heroism, and appreciated the alleviating humour which helped to make life reasonable. Anne Chalmers Hanna (1813–1891), Thomas Chalmers's eldest daughter, who appears as one of the family group with her restless son, is also pictured in a more relaxed position [43]. Only one of her sons had survived and her daughter wrote:

> *The deaths of these babies deeply affected her... [but] my mother*
> *was not a universal adorer of all infants. A cousin once told me*
> *that when her mother had a young baby, and was showing it with*
> *pride to mine, after duly admiring the little person, my mother*
> *said, 'Now let us send away the baby and get the cat.'*[40]

The calotypes demonstrate Hill's affection for women as independent individuals. He knew them as well as the men of his circle. One of the most notable of Hill and Adamson's collaborators in the calotype work was the journalist and critic, Elizabeth Rigby [46]. She was their familiar model for photographs, and wrote an impressive passage of praise for their work in the *North British Review* in 1846. In this she expressed the decided opinion of Hill and Adamson's, 'beautiful and wonderful Calotype drawings', and noted that 'Every truth that art and genius has yet succeeded in seizing here finds its prototype. Every painter, high or low, to whom Nature has ever

[46] Elizabeth Rigby, Lady Eastlake

'For more than fifty years, she was a notable figure in Edinburgh and London society as the brilliant and imposing Miss Rigby and afterwards as the wife of Sir Charles Eastlake, President of the Royal Academy and Director of the National Gallery.' Elizabeth Rigby was one of Hill and Adamson's keenest collaborators, appearing in more calotypes than any other figure than Hill himself.

revealed herself, here finds his justification.'[41] Elizabeth Rigby was an independent and opinionated woman, who believed in the necessity for companionship between men and women and wrote: 'Man requires the resistance as well as the co-operation of the female partner in life.'[42] Hill clearly enjoyed her company. After she married the painter, Charles Eastlake, in 1849, Hill wrote of her as: 'my old sweetheart Elizabeth Rigby – the tallest, cleverest & best girl of these parts'.[43] Her mother, Mrs Anne Rigby (1777–1872), bore twelve children, including quadruplets when she was forty. She was widowed in 1821 and outlived her husband by more than fifty years; amazingly, she presents a calm and smiling picture of old age [45]. In the 1840s Mrs Rigby was a friend of Mrs Whistler, so the slightly disconcerting descriptive resemblance between this portrait and James McNeil Whistler's portrait of his mother, later in the century, may not be a coincidence.

The Free Church move to a greater freedom is echoed in other areas of life. Henry Vincent (1813–1878) was one of the Chartists, who fought for universal suffrage [44]. Anna Jameson (1794–1860), who began her career as a governess, made an unsuccessful marriage with a lawyer and, thereafter, earned her own living as a writer and art historian, stood out for educational and legal freedom for women, and the need to recognise 'the principle of justice and equality' [47].[44]

[47] Anna Brownell Jameson

Mrs Jameson married a lawyer, after beginning her career as a governess. But the marriage proved unsuccessful and she worked thereafter as a writer and art critic. She was a champion of women's rights to their own property and education. She was a friend of Lady Eastlake (Elizabeth Rigby), who finished the final volume of her series on the history of Christian art, after her death. The sculptor, John Gibson, greatly admired this 'splendid portrait', which he framed and hung on the wall of his studio in Rome.

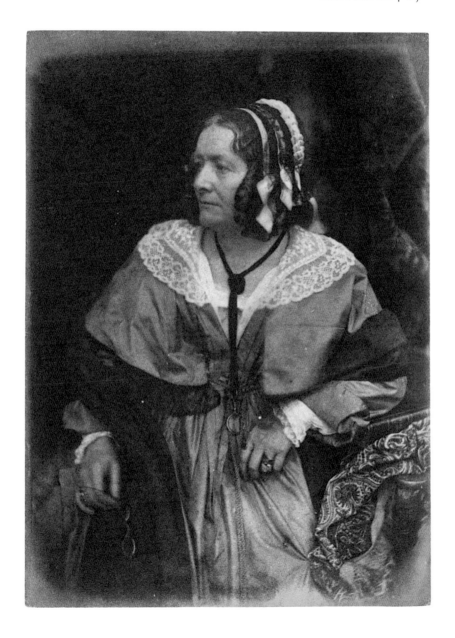

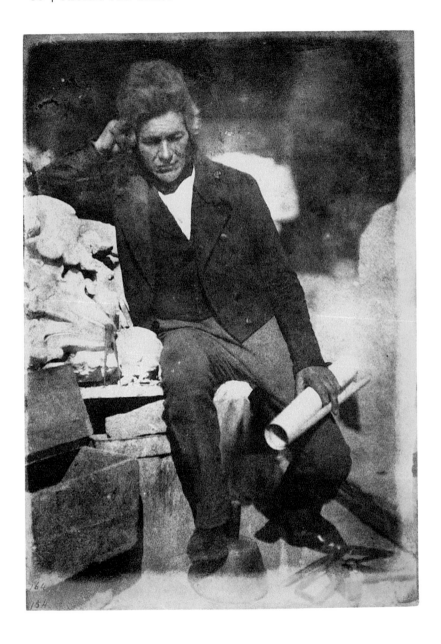

Figures like George Meikle Kemp (1795–1844) or Hugh Miller were self-made men. Kemp started his working life as a carpenter, travelling between the great cathedrals of Europe to study their architecture, and he subsequently won the commission to build the Scott Monument in open competition [**48**]. Hugh Miller was a stonemason, geological collector, author, banker, poet and, in the 1840s, the editor of *The Witness* newspaper which fought the battles of the Free Church [**10**]. Hill placed him in the foreground of the Disruption picture and wrote that his was:

> ... *a name very dear to Scotland, and admired wherever the English language is read – whose figure does not bulk more prominently in the picture than did his remarkable writings in the controversy evolving from the Disruption, of which it may be said emphatically he was one of the greatest leaders.*[45]

Many of the calotypes celebrate admirable talent and character in fields as far apart as music and athletics. Mr Laing wields a tennis racket [**49**]. Captain Robert Allardyce (1779–1854) was a 'celebrated pedestrian' [**52**]:

[48] George Meikle Kemp

G. M. Kemp started life as the son of a shepherd, and worked as a carpenter. He travelled throughout Europe as a stonemason, studying the great Gothic cathedrals. He returned in 1826, on the death of his mother, and worked as an architectural draughtsman. His great chance came in 1838, when he won the competition to build the Scott Monument. He superintended the building of the monument until the night of 6 March 1844, when he fell into the Union Canal on his way home and drowned. 'Kemp was a man of retiring and studious disposition, possessing an almost child-like simplicity of manner. His conversation was at all times interesting and instructive, but especially on the subject of gothic architecture, of which he would discourse in language full of animation and simple eloquence.'

*On the tenth of November (1801) he completed the performance
of one of his most notable feats, walking ninety miles in twenty-
one and a half successive hours, on a bet of 5000 guineas. Some
years later, the task of walking 1000 miles in 1000 successive
hours, a mile within each hour, in which many before had failed,
was undertaken by Barclay, and about £100,000 was staked on
the issue. He began his course at Newmarket, at midnight on 1st
June, and duly finished it at 3 p.m. on the 12th July, amidst a
vast concourse of spectators… The pain undergone by the gallant
captain is understood to have been excessive; he had often to be
lifted after resting, yet his limbs never swelled, nor did his
appetite fail; and five days after, he was off upon duty in the
luckless Walcheren expedition.*[46]

Hill's enthusiasms embraced the past and the present, Scotland and the wide
world. He could see history in a landscape, and would happily paint the new
railways driving through. The blind Irish harper, Patrick Byrne (1797?–
1863), was calotyped both in his customary suit and draped in a blanket
[**50**]; Hill remarked: 'The Harper, whose costume is made of a blanket and
plaid shows how simply one might get up pictures of the old world.'[47]

This sense of people who belonged to an earlier age can be found in
the extraordinary Highland portrait of Charles Sobieski Stuart (1799–1880)
who, with his brother claimed legitimate but secret descent from Bonnie
Prince Charlie [**51**], or in other pictures such as Mrs Burns Begg (1771–
1858), sister of Robert Burns (1759–1796), who is calotyped as the living

[**49**] **Mr Laing, 1843**

This picture is an attempt at action photography. Because the
exposure time must have been at least a few seconds, struts,
positioned at his back, support the young man and the racket may
be held up with string.

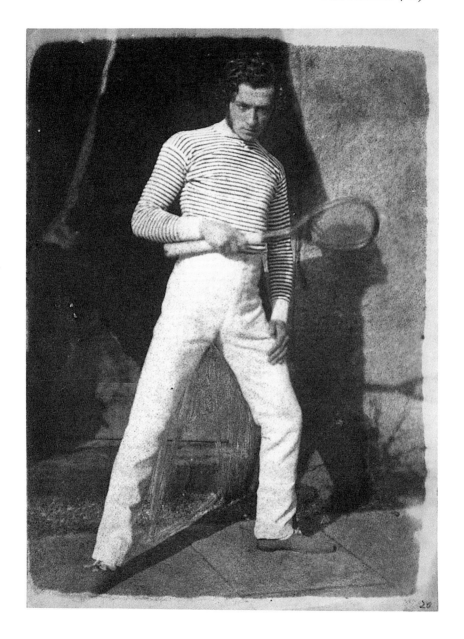

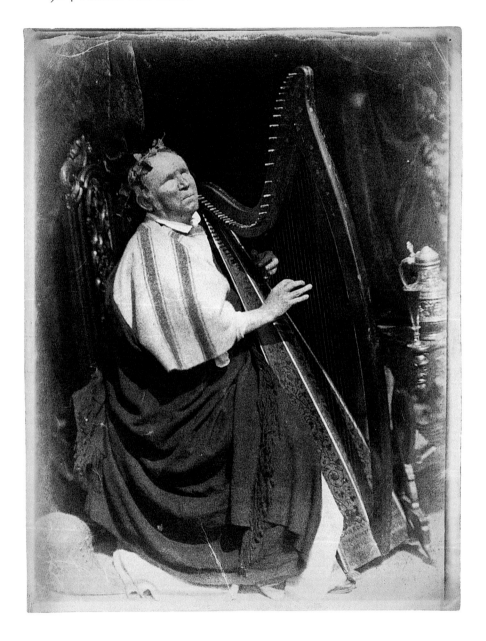

evidence of the poet [53]. Walter Scott is represented by his granddaughter, the child he had called his 'little whippety-stourie', for her energy, here shown on the edge of adulthood and marriage [54]. Mary Campbell, Lady Ruthven (1789–1885) was a friend and contemporary of Sir Walter Scott and commissioned one of the last portraits of him by Sir Francis Grant. She would not allow Grant to touch the incomplete painting after Scott's death and she took pride in showing it, a cherished possession, in its unfinished state [55].

Some of the calotypes avoid the tedium of nineteenth-century dress by showing people in historic or exotic costume. The painter, William Leighton Leitch (1804–1883), shaved his head to impersonate a monk [35]. A group identified as Mr Lane and Mr Peddie, is known as 'Circassians' or 'Afghans' [36]. The armour they wear may have come from the collection of the painter, William Allan, but Britain was at war with Afghanistan in 1841 and the armour may have been brought back by soldiers fighting there. It is more extraordinary that an Afghan, Mohun Lal [56], arrived in Edinburgh in October 1844. He had been the companion of the government agent, Sir Alexander Burnes (1805–1841) and accompanied him to Bokhara in the 1830s. During the fighting in Kabul in 1841, Burnes, who had advised against the war, was killed. After his death, Mohun Lal had 'at the risk of

[50] **Patrick Byrne**

Patrick Byrne was the famous blind musician who visited Edinburgh in 1843–4. He was educated at an academy in Belfast set up to teach the harp to the blind – in a conscious echo of such legendary figures as Ossian, the heroic harpists of history. He performed in a tableau at one of the Waverley Balls, as 'The Lay of the Last Minstrel' and Hill wrote of the calotype: 'The Harper, whose costume is made of a blanket and plaid shows how simply one might get up pictures of the old world.'

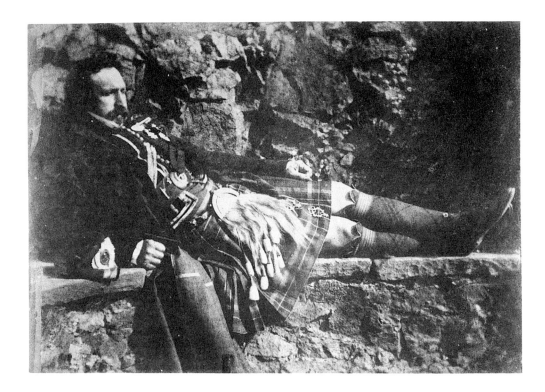

[51] Charles Edward Stuart

Charles Edward Stuart, otherwise known as
Hay Allen, was one of the Sobieski Stuart
brothers who claimed legitimate descent from
Bonnie Prince Charlie. They lived on an island
in the River Beauly, in a house hung with tartan
and stags' antlers, and published works on
Highland costume. Scott remarked temperately
that they were men of 'somewhat warm
imaginations'.

[52] Captain Robert Barclay-Allardyce

'… the task of walking 1000 miles in 1000
successive hours, a mile within each hour, in
which many before had failed, was undertaken
by Barclay, and about £100,000 was staked on
the issue. He began his course at Newmarket,
at midnight on 1st June, and duly finished it at
3pm on the 12th July …'

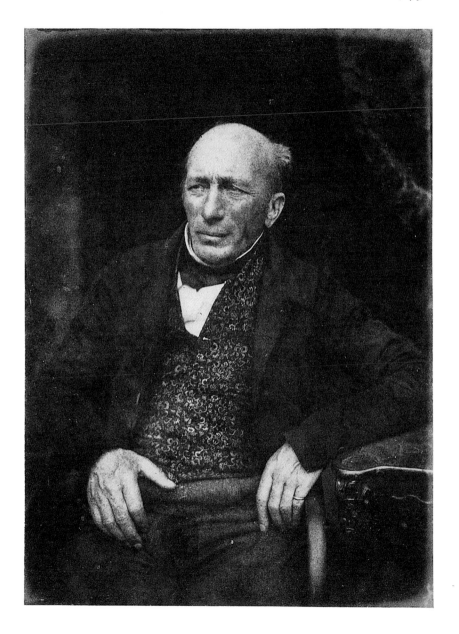

his life entered Sir Alexander's mansion when it was in flames and secured his private papers', and travelled to Scotland to return them to Burnes's family in Montrose. The newspaper report added: 'He has a remarkably pleasant and highly intellectual cast of countenance, and is dressed in a magnificent Hindoo costume.'[48]

In 1845, Hill and Adamson took the first photograph of a Native American, the Revd Peter Jones or Khakewaquonaby (1802–1856) of the Ojibeway tribe [57]. He was a Christian convert – the son of an Ojibeway woman and a Welsh Methodist. He came to Scotland to raise money for manual labour schools to reconcile his beleaguered tribe to Christianity and western ideas of life. For the Free Churchmen, he was a remarkable figure – living proof of the assimilation of the virtues of the savage and the civilised. Hugh Miller met him and wrote:

> In general, we would say, that he quietly reaches, by the
> intuitions of the soul, what we, strong-lunged, tough-sinewed
> Europeans, scorn to reach by any other way than by elaborate
> and exhaustive ratiocination. He follows nature's path,
> contentedly and confidingly, through forest and prairie; we must
> bore, and blast, and tunnel, pile up arches and bridges, like so
> many Titans, before we can get a road worthy of our travelling.[49]

[53] Mrs Isabella Burns Begg

Mrs Burns Begg was the youngest sister of Robert Burns. She was left a widow with nine children in 1813, and earned her living by keeping a school. She was in her seventies at the time the calotype was taken. The challenging, full-face pose is designed to echo the full-face portrait of her brother by the artist, Alexander Nasmyth.

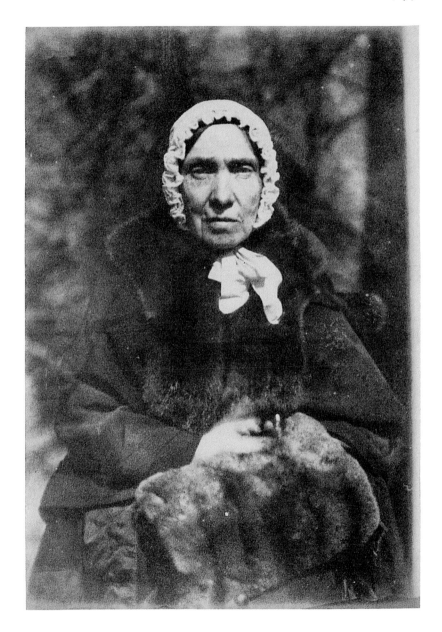

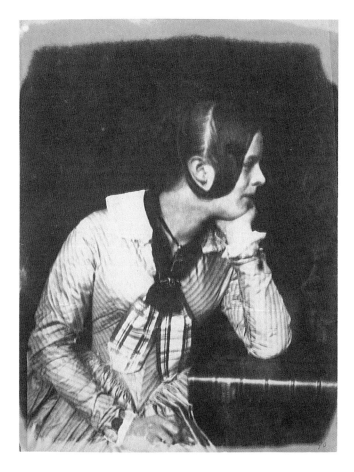

[54] Charlotte Lockhart, later Mrs Hope

Charlotte Lockhart was the granddaughter of Sir Walter Scott.
She was described at this time by her husband's biographer, James
Hope, as 'a very attractive person, with a graceful figure, a sweet
and expressive face, brown eyes of great brilliance, and a beauti-
fully shaped head: the chin, indeed, was heavy, but this added to
the interest of the face by its striking resemblance to the same
feature in her great ancestor, Sir Walter Scott'.

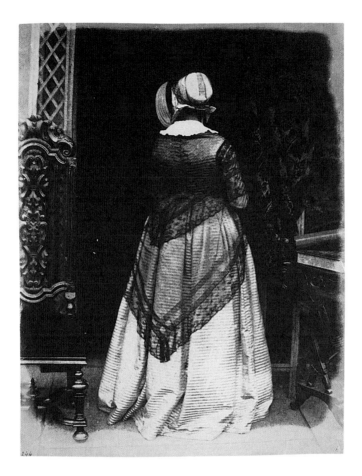

[55] Mary Campbell, Lady Ruthven, 1847

Lady Ruthven was both a painter and patron of the arts. It was said of her:
'She was not only the friend of Walter Scott, but she held relations more or less
close with nearly everyone famous in art and literature, during the greater part of
the nineteenth century.' Hill sent her a batch of calotypes, in December 1847, and
commented 'Lady Haddo's and Miss Baillie's are not what in better circum-
stances we could hope – and so I may say of your own & Lord Ruthven's
portraits – yet, yours especially indicates what could be done in this direction,
with good sitters, good backgrounds & good sunshine. indeed with these
appliances a wonderful little family gallery might be made in a few days & to
such uses I doubt not the Calotype will come.'

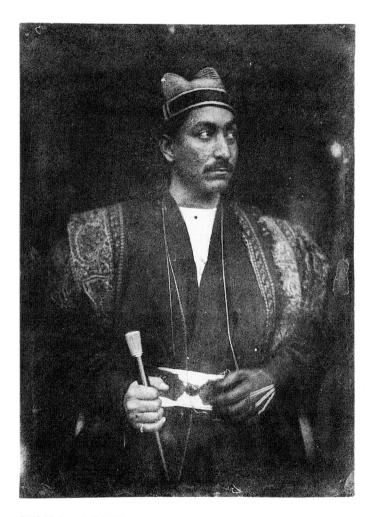

[56] Mohun Lal, 1864

Mohun Lal, arrived in Edinburgh in October 1844. He had been the companion of the government agent, Sir Alexander Burnes (1805–1841), in Kabul in Afghanistan. After his death, Mohun Lal had 'at the risk of his life entered Sir Alexander's mansion when it was in flames and secured his private papers', and travelled to Scotland to return them to Burnes's family in Montrose. The newspaper report added: 'He has a remarkably pleasant and highly intellectual cast of countenance, and is dressed in a magnificent Hindoo costume.'

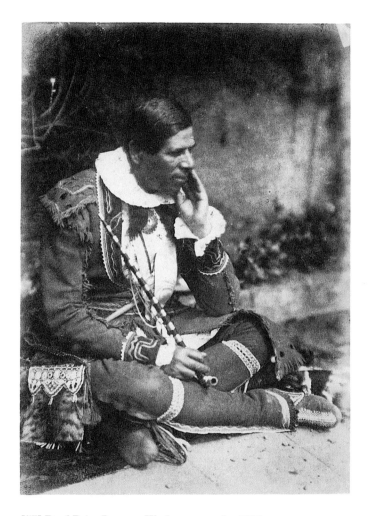

[57] Revd Peter Jones or Khakewaquonaby, 1845

In 1845, Hill and Adamson took the first photograph of a Native American, the Revd Peter Jones or Khakewaquonaby (1802–1856) of the Ojibeway tribe. He was a Christian convert – the son of an Ojibeway woman and a Welsh Methodist. He came to Scotland to raise money for manual labour schools to reconcile his beleaguered tribe to Christianity and western ideas of life. For the Free Church-men, he was a remarkable figure – living proof of the assimilation of the virtues of the savage and the civilised.

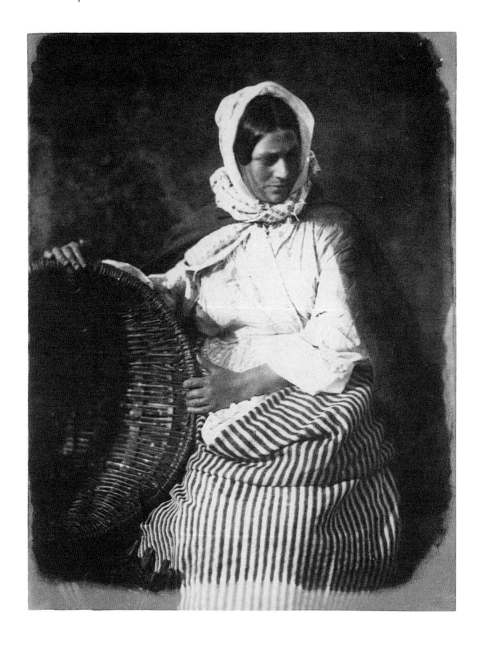

The Fishermen and Women of the Firth of Forth

In the late eighteenth and early nineteenth century, the city of Edinburgh broke the defensive line of the Old Town on the spine of volcanic rock running between the castle and the Palace of Holyrood. The loch on the north side was drained and turned into a park and, beyond, the architects established the orderly neoclassical streets and squares of the New Town. The new houses attracted the wealthy, who left the Old Town to the poorer people. By the 1840s, the historic Old Town was overwhelmed by disease and poverty. With the steep rise in urban population, and the economic slumps, which alternated with the booms in industrialisation, the tall, old buildings had turned to crowded slums. In the Revd Dr Thomas Guthrie's words: 'whole streets, once from end to end the homes of decency, and industry, and wealth, and rank, and piety, have been engulfed [by] a flood of

[58] **Elizabeth Johnstone Hall**

This calotype was variously captioned by Hill, 'A Newhaven Beauty', and 'It's no fish ye're buying it's men's lives'. His admiration for the fishwife is expressed through the strong and beautiful composition which brings out her personality as well as underlining the heroism and danger in her alliance with her husband out at sea.

ignorance, and misery, and sin.'[50] Guthrie established 'ragged schools', which took the children in from the streets, and fed and educated them, to give them a future. He was assisted by Dr George Bell (d.1888) who was described as 'an estimable, upright, and loving man … of great industry and full of zeal for humanity'. Bell was also a close friend of Hill, and collected the facts of the problem as well as trying to find appropriate answers.[51]

Hill and Adamson did not respond in the way we might expect. They did not photograph the distressed people of the High Street, to present their shocking circumstances to a wider world. They followed a different line of thought, tried out by the Revd Thomas Chalmers and recommended by Bell. The progress in industrial and agricultural production and wealth stimulated population growth, and both encouraged, through opportunities for new work, and forced, through the Highland Clearances and the potato famine, people into the cities. The problem was one of social damage. The slums were largely inhabited by people coming in to the cities, who met as strangers, and had no society to protect them in times of distress.

In 1819, Thomas Chalmers had tried a practical solution to the slums of Glasgow. He took over one of the largest and poorest districts, and closed the parish from outside poor relief – keeping his people together with the aid of deacons and elders, paying attention to them and re-building the natural impulse of generosity and neighbourliness. He and his successor succeeded in keeping the community together in conditions of severe

[59] Sandy Linton, his Boat and Bairns

Newhaven survived as an effective community through its close relations with family and friends. This picture shows Sandy Linton with his sons, sheltered by the boat which gives them their living. He stands protectively by them, and he is training them in his own skills in the knowledge of fishing and the handling of the boat.

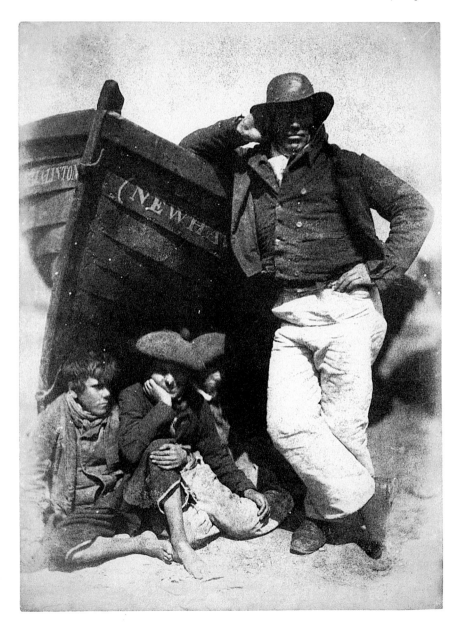

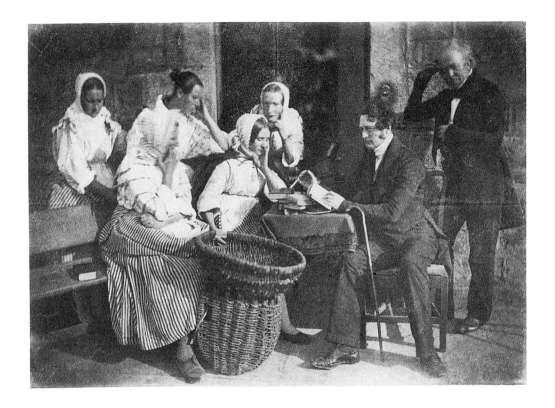

[60] The Pastor's Visit, 18 July 1845

This group of fishwives, which includes Mrs Carnie Noble, Bessy Crombie, Mary Combe and Mrs Margaret Lyall, were the wives of elders or actively engaged in church work. The minister, James Fairbairn, was probably chosen by the congregation for 'the expressive manner in which he prayed for men exposed to peril by sea'. Fairbairn also owned an impressive library: 'it was no unusual spectacle to behold him in the middle of town, his coat pockets stuffed with minor volumes, while a couple of larger tomes, or even a huge folio, would be at the same time stuck under his arms... On occasion he was spied out by some stalwart fishwives, who accosted the doctor to carry his books in the bottom of their big creels – odorous of cod, haddock or herring.'

economic distress for twenty years. In 1849, George Bell recommended a similar plan, to attack the problem of Edinburgh's slums, by taking over wasteland and returning the displaced agricultural workers, who had come into the city, to small coherent communities.

The natural model of the kind of society Chalmers and Bell sought – a stable society, small-scale, independent, self-sufficient, morally alive and culturally sophisticated – stood on the shores of the Forth at Newhaven, just over a mile away from the city. The ironic descent from the Old Town crowned with slums to the moral example of this fishing village, a practical working community, was in a sense too obvious to miss. The Newhaven photographs advertised in 1844 in Hill and Adamson's list of publications as *The Fishermen and Women of the Firth of Forth* can be considered as Hill's response and contribution to the debate.[52] Hill's admiration for Newhaven is undoubted and the photographs may be read as an analysis of praise as effective as the reports condemning the slums. It seems reasonable that the intention in photographing Newhaven was not merely to celebrate its surface attractions but to analyse through visual art the way the village had survived and coped through the social confusion and distress of the Industrial Revolution and its aftermath; a way which maintained social dignity and remained both morally truthful and visually beautiful.

Newhaven, like Chalmers's Glasgow parish, was socially isolated. The fishing and the preparing, carrying, and selling of the fish in the city involved both phenomenal skill and labour. It was a profitable business but highly dangerous. The Newhaven men were skilled fishermen, working from open boats both in the inshore fishing with the 'small line', which could carry from 500 to 3,000 hooks to catch haddock, whiting and codling, and in the 'great line' fishing out at sea. Every year, during the herring season, the Newhaven fishermen moved about 200 miles north to Wick for six to eight weeks, 'no inconsiderable journey as it was often the custom to row the entire distance'.[53] There the men fished at night, bringing back in

the twenty years up to 1840, an impressive catch, averaging 88,500 barrels a year, with roughly 800 fish in each barrel. Many of the fishwives travelled with the men to the fishing grounds to gut and cure so great a catch. James Wilson, who saw the fishwives at work, covered in the blood and slime of the fish, was stunned by the sight: 'From what we witnessed of their prowess, we doubt not that if arranged in battle array they would have gained the day at Waterloo.'[54]

The skill of the Newhaven men was made publicly clear after a disastrous summer storm in 1848, at Peterhead. A hundred men drowned, leaving 47 widows and 161 orphans. However, none of the men who drowned were from Newhaven. A parliamentary enquiry pointed to the lack of safe harbours and the poor design of the boats. The Newhaven boat was declared the second worst in use. The report concluded: 'The character the Firth of Forth boats are said to bear, of being fine sea-going boats, must be attributable more to the skill of the crews than to the form of the boats.'[55] The final ironic comment is useful evidence of the truth of the Newhaven fishermen's professional skills. Many of them qualified as pilots and took pride in their readiness to volunteer in times of war. The Newhaven pilots also achieved a reputation for heroism, particularly during the Napoleonic Wars.

The women did most of the land work; they prepared the fish and carried them in hundredweights up into the town to sell, which gave them both confidence and independence. The actress, Fanny Kemble, a friend of one

[61] **Alexander Rutherford, William Ramsay, and John Liston**

This strong portrait of three self-confident men is given emphasis by their relaxed pose and the way they form a solid, mutually supportive group around the boat. Their clothes, shaped and battered by the work at sea, express the muscle beneath, and the hats give a proper individuality.

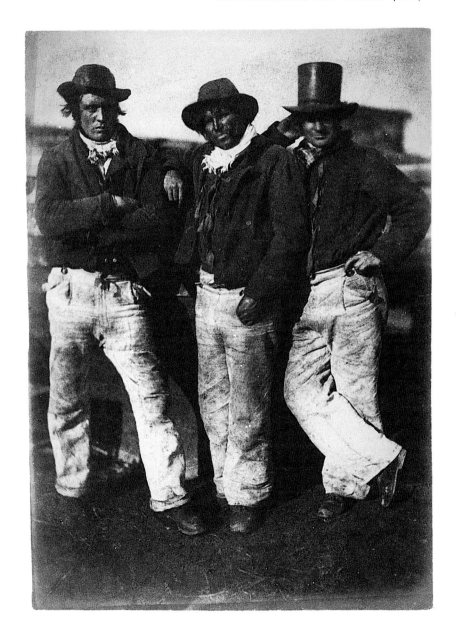

of the fishwives, spoke of them with unequivocal admiration: 'It always
seemed to me that these women had about as equal a share of the labour of
life as the most zealous champion of the rights of her sex could desire.'[56]
The distinctive dress and the beauty of the fishwives made them a natural
tourist attraction, their strong and heroic character made them admirable.
Hill captioned the photograph of Elizabeth Johnstone Hall with her name,
or as 'A Newhaven Beauty' [58]. In one album, he wrote: 'It's no fish ye're
buying, it's men's lives.'[57] This was a customary remark, when stormy
weather raised the price of fish. For Hill, the true beauty of the fishwife was
connected to her life and hazardous affections – the essential partnership
with the men, often absent at sea and absent from the photograph.

Hill and Adamson's calotypes aimed to show both the work and the
protective social structure of the village – the close relationship between
individual fishwives, who formed friendships in youth and supported each
other, or the protective, educational relationship of father and sons [59].
In contrast to the photograph of Sandy (or James) Linton and his bairns,
the only photography of a child standing by himself was called 'His
Faither's Breeks', indicating his status as an orphan [65]. The fishermen and
women married amongst themselves, reared their children in the knowl-
edge of fishing and the sea and, by close alliance, protected the community
against individual disaster. They formed a Free Society of Fishermen to
defend their legal rights and to protect the widowed and orphans. The
calotypes go beyond the practical and family view of the village and give
us also an idea of its cultural and moral status. There are two calotypes of
fishwives reading a letter, a new literacy and a new ability to communicate
with their families abroad [66]. In other photographs, a fishwife and a
fishermen are shown deep in thought, and an idea of their known skill as
singers is brought out in the captions Hill gave the calotypes [64].

The village joined the Free Church, and the fishwives are seen read-
ing in a Bible class with the minister, the Revd James Fairbairn [60]. Their

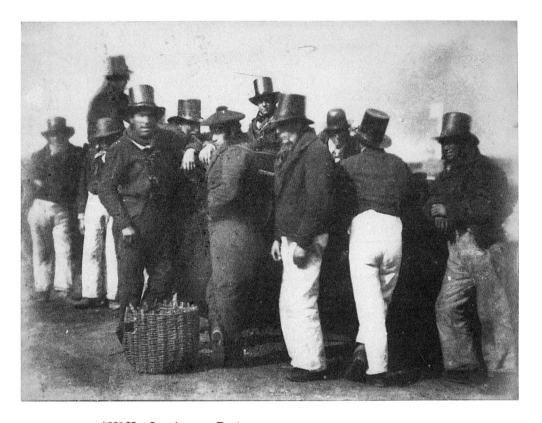

[62] Men Leaning on a Boat

After the phenomenally strenuous work at sea, the fishermen returned to land to rest. Cynical landsmen with no idea of the labour of the fishing looked at the fishermen lolling at ease and thought them idlers.

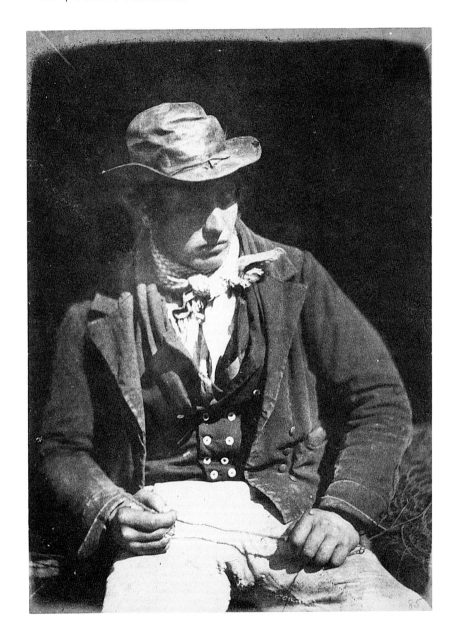

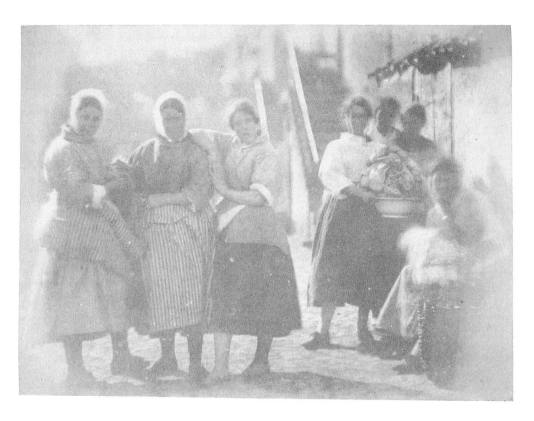

[63] Willie Liston, 'Redding the line'

This dramatic portrait of Willy Liston is a study in concentration, as he cleans and baits, with mussels, the hundreds of hooks on the line – a meticulous and lengthy task. The dark shadow across his face helps to focus attention on the work of his hands.

[64] Fishwives with Washing

Hill gave this photograph the caption of a song;
The herring loves the merry moonlicht
The mackerel loves the wind
But the oyster loves the dredging sang
For it comes of the gentle kind

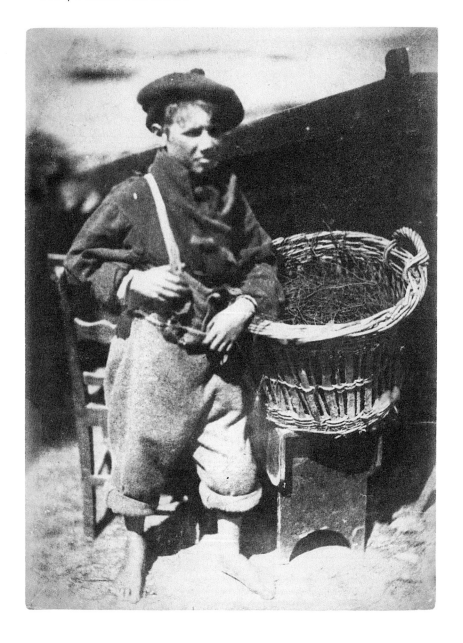

religious enthusiasm was underlined publicly in 1844. The Revd Robert Macdonald had initiated a fund to encourage the building of 500 new schools in Scotland. He travelled around Britain preaching and lecturing, with the aim of raising £50,000. In January, Macdonald spoke to the congregations at Leith and received the gift of nearly £300 from Newhaven made 'chiefly by his good friends the fishermen'. *The Witness* commented on this, as a fact illustrating:

> *the effect of the faithful preaching of the gospel in enlightening the*
> *understanding and enlarging the hearts of the poorest and hardest-*
> *working classes of the community. If we remember correctly, it was*
> *reported at the recent Scottish Episcopal Church Society meeting,*
> *that the united aristocracy of Scotland contribute, for education in*
> *their own favourite church £153 … The Newhaven fishermen*
> *exceed the nobles of Scotland in enlightened liberality, for the*
> *education of the youth of the nation, by £147.*[58]

Hill had painted in Newhaven in earlier years, but the close association demanded by photography may well have given him a clearer insight. The first proposal was to produce about twenty or twenty-five photographs for publication. Hill and Adamson took about 120, single portraits and groups of numbers up to twenty-six men, women and children. The generous collaboration and the organisation behind this must have been extraordinary. The photographs were all taken out of doors, and mostly, in film terms, on location. They have a resemblance to film stills, simply because they were

[65] **'King Fisher' or 'His Faither's Breeks'**

This is the only Newhaven child who is shown alone in a calotype. The title implies that the lad has inherited his father's work and responsibilities. He is not just poor, he is an orphan, whose father may well have been drowned at sea. He is obliged to take on the problems of adult life before he is large enough to fit the trousers.

all carefully arranged; their remarkable appearance of nature implies that Hill had watched, talked and listened, before deciding what to take and how to do it. Hill expressed the difficulty of photography a little oddly. He wrote: 'The arrangement of the picture is as much an effort of the artist as if he was in reality going to paint it.' More importantly, when talking about portraits, he said: 'Coldness on the part of those to be represented would I fear unman me quite.'[59] This means that he needed to generate an amiable and sociable atmosphere, to set up a relationship with his subjects, before he could take effective calotypes. The very facts imply an impressive admiration and respect for Newhaven.

Hill and Adamson's ability to work with the calotype process, discovering what it might do, as well as deciding what it could be persuaded to do, is one of the secrets of their success. Much of their practice can be connected to previous experience in graphics, whether drawing or printmaking. But the only precedent for the idea of studying the working lives of a community lies in the analytical study of exotic foreign cultures. The Newhaven project was a large-scale collaborative study of local working life. This invention of social documentary photography was extraordinary and was only followed up a hundred years later, in the twentieth century. Hill and Adamson's photographic idea was well ahead of its time.

[66] The Letter

The new penny post enabled the literate working classes to communicate properly across distance for the first time, a matter of great importance to the fishwives whose men might be driven off course or shipwrecked at sea. The subject of a letter was familiar in painting from the work of Dutch seventeenth-century artists. As a theme, it has the attraction of focusing the attention of the women, whilst leaving us speculating – What is in the letter? Is it sad or happy? How will the women react?

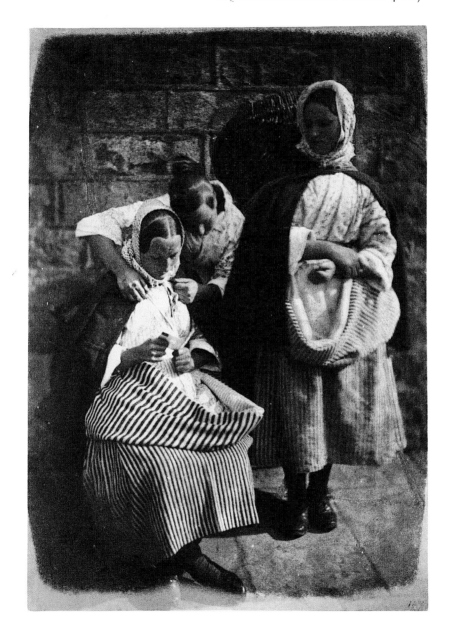

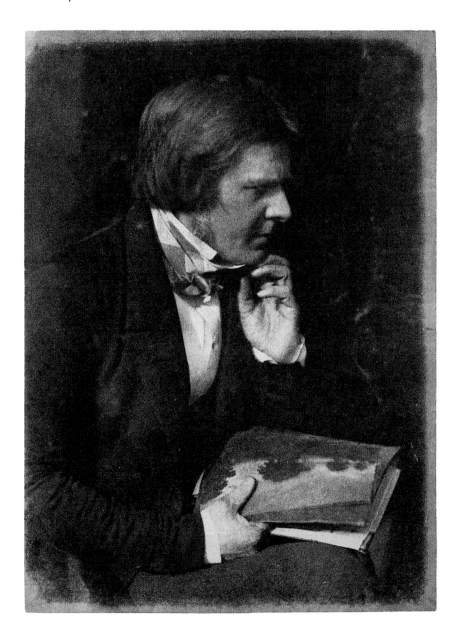

After Adamson

Even when working in the calotype partnership in 1845, Hill was troubled that he was neglecting his painting. When reading John Ruskin's *Modern Painters*, he commented: 'The exalted views ... of Landscape Painting made me, as well they might, blush for the truant part I had played from a noble profession.'[60] After Robert Adamson's death in 1848, Hill effectively gave up photography. He returned to the practice of landscape and to his profession as the secretary of the Royal Scottish Academy, where he was a notable promoter of the Scottish arts, responsible not just for the annual exhibitions but very active in such major projects as the setting up of the National Gallery of Scotland.

[67] **David Octavius Hill 1802–1870**

This portrait of Hill shows him with a landscape sketch. The difficulty of telling if this is a photograph, engraving or watercolour emphasises the connection between the earlier arts and the calotype photographs. An enthusiastic review of Hill's landscape work and calotypes together, written in 1846, concluded: 'Mr Hill has as many faults, but more beauties, – greater reach of imagination, – more of the true poetical temperament, – more power of rendering his own, and bringing out the emotions of others, – in a word, more *genius*, than any other of our native landscape painters.'

But Hill's impact on photography persisted. In 1851, he gave the Academy five hundred calotypes as the basis of a national collection of photography, and said then that he had influence with 'not a few of the calotypists' and hoped to add their work as well. In the 1850s especially, he continued to exhibit the photographs and, as the decade progressed and they were compared with 'improved versions' of the art, their excellence was more fully appreciated. Hill's later authority in the field may be charted through the work of many of the Scottish photographers at home and abroad, such as Dr Thomas Keith in Edinburgh, Alexander Gardner in the United States, William Carrick in Russia, or John Thomson in China. Hill maintained a direct connection with Dr John Adamson, who emerged as an impressive portrait photographer in the mid–1850s. He also worked with Thomas Annan, who expressed: 'an intense admiration and appreciation of Hill as a man and as an artist'.[61] Hill undertook a further brief alliance with a professional photographer, Alexander McGlashan around 1860, taking about twenty photographs in the smoother and clearer albumen process, but the results are not as effective as the calotype work.

It was principally J. Craig Annan, Thomas Annan's son, who introduced the calotypes to the twentieth century. He made photogravures of some of the work, which he exhibited and published in Alfred Stieglitz's prestigious journal *Camera Work* – ensuring a world audience amongst the photographers. The calotypes became a touchstone of nature for the international Pictorialist movement and were embraced by the Modernists in turn – such figures as Paul Strand and Ansel Adams. Hill, himself, came to be seen as a father of modern photography, and the partnership's work offered as great a challenge to the twentieth century as it did to the nineteenth. Strand wrote: 'The results of Hill's experimenting have given us a series of amazing portraits … They remain the most extraordinary assertion of the possibility of the utterly personal control of a machine, the camera.'

It took David Octavius Hill twenty-three laborious years to finish the Disruption picture, which he completed with the aid of his second wife, the sculptor, Amelia Paton, in 1866. In the prospectus for the painting, Hill referred to the calotypes taken with Adamson as, 'first raising the process to the rank of a Fine Art, or rather to that of one of its most magical and potent auxiliaries'.[62] Few contemporary painters would have expressed so much enthusiasm for photography. The intervening years had increased his own admiration and understanding of the remarkable achievement of the Edinburgh partnership in the sunny years of the 1840s.

Notes

1 Henry Cockburn, *Memorials of his Time*, Edinburgh 1856, pp.80, 82 and 167.

2 As note 1, pp.168–9.

3 Forbes to his sister, 20 May 1839, discussed by Graham Smith, 'James David Forbes and the Early History of Photography', *Shadow and Substance. Essays on the History of Photography in Honor of Heinz K. Henisch*, ed. Kathleen Collins, Michigan 1990, pp.9–11.

4 John M. Gray, 'Robert Adamson', *Calotypes by D.O. Hill and R. Adamson Illustrating an Early Stage in the Development of Photography Selected from his Collection by Andrew Elliot*, Edinburgh 1928, p.11. John Miller Gray's information probably came from Dr John Brown, a friend of Hill.

5 Mrs Oliphant, *Thomas Chalmers*, London 1905, pp.231–2.

6 Advertisement in *The Witness*, 24 May 1843.

7 Hugh Miller, 'The Two Prints,' *The Witness*, 24 June 1843.

8 Brewster to Talbot, 3 July 1843, National Museum of Photograpy, Film and Television 1937–4926.

9 *The Witness*, 12 July 1843.

10 Sir Thomas Dick Lauder to Hill and Adamson, 22 December 1843, MS in the Royal Scottish Academy.

11 Brewster to Talbot, National Museum of Photograpy, Film and Television 1937–4928.

12 Noted in *The Witness*, 17 January 1844.

13 James Nasmyth to Hill, 27 March 1847, MS in the Royal Observatory, Edinburgh.

14 Carl Gustav Carus, *The King of Saxony's Journey through England and Scotland in the year 1844*, trans. S.C. Davison, London 1846, p.337.

15 Letter to the Editor, *Photographic Journal*, 1859, vol.6, no.103, p.264.

16 Quoted by Heinrich Schwartz, 'The Calotypes of D.O. Hill and Robert Adamson: Some Contemporary Judgements', *Apollo*, February 1972, p.124.

17 Hill to David Roberts, 12 March 1845, National Library of Scotland TD 1742.

18 Hill to David Roberts 14 March 1845, National Library of Scotland TD 1742.

19 Hill to David Roberts, 12 August 1847, current whereabouts of manuscript unknown.

20 Lord Cockburn to Hill, 28 October 1847, National Library of Scotland Acc 11782.

21 Robert Louis Stevenson, 'The Manse,' *Memories and Portraits*, London 1925, p.62.

22 Hill to Joseph Noel Paton, 18 January 1848, National Library of Scotland Acc 11315.

23 Hill to Henry Bicknell, 17 January 1849, George Eastman House Collection, MS AC H645 acc 830.

24 Hill to David Roberts, 12 March 1845, National Library of Scotland TD 1742.

25 Hill to C.G.H. Kinnear, 14 December 1856, Royal Scottish Academy archives.

26 The idea had been patented on a small-scale by Alexander Woolcott in America and England, in 1841.

27 John Brown, review of the Royal Scottish Academy exhibition, *The Witness*, 22 April 1846.

28 Paul Strand to Beaumont Newhall, 28 April 1953, quoted in Sarah Greenough, *Paul Strand. An American Vision*, Washington 1990, p.128

29 David Brewster to Henry Fox Talbot, 28 November 1843, National Museum of Photograpy, Film and Television 1937–4929.

30 Henry Cockburn, *Memorials of his Time*, Edinburgh 1856, p.91.

31 *James Nasmyth, Engineer, An Autobiography*, ed. Samuel Smiles, London 1891, p.336.

32 Richard L. Hills, *Papermaking in Britain 1488–1988*, London 1988, p.123.

33 Quoted in Revd Thomas Brown, *Annals of the Disruption*, Edinburgh 1884, pp.747–8.

34 Mrs Oliphant, *Thomas Chalmers*, London 1905, p.205.

35 John Brown, 'Dr. Chalmers,' *Horae Subsecivae*, London 1908, pp.114–15.

36 Thomas Guthrie, *Speaking to the Heart or Sermons for the People*, London 1862, p.145.

37 *The Autobiography of Thomas Guthrie, D.D. and Memoir by his sons, Revd David K. Guthrie and Charles J. Guthrie*, London 1875, vol.2, p.70.

38 Quoted in Revd Thomas Brown, *Annals of the Disruption*, Edinburgh 1884, p.188.

39 Hugh Miller, 'Characteristics of the Crimean War,' *Leading Articles on*

Various Subjects, ed. Revd John Davidson, Edinburgh 1870, p.298.

40 Quoted in *The Scotswoman at Home and Abroad*, ed. Dorothy McMillan, Glasgow 1999, pp.193–4.

41 Elizabeth Rigby, review of books on modern German painting, *Quarterly Review*, March 1846, p.338.

42 Quoted by Marion Lochead, *Elizabeth Rigby, Lady Eastlake*, London, 1961, p.7.

43 Hill to his sister-in-law, Jane Macdonald, July 1853, National Library of Scotland Acc 11782.

44 Quoted in Deborah Cherry, *Beyond the Frame. Feminism and Visual Culture, Britain 1850–1900*, London and New York 2001, p.19.

45 Anonymous (presumed to be D.O. Hill), *The Disruption of the Church of Scotland: An Historical Picture*, Edinburgh 1866, p.16.

46 Robert Chambers, *The Book of Days*, London and Edinburgh 1888, vol.1, p.609.

47 Draft letter, Hill to Lady Ruthven, December 1847, Royal Scottish Academy archives.

48 *The Witness*, 23 October 1844.

49 Hugh Miller, *The Witness*, 26 July 1845.

50 Quoted in *The Autobiography of Thomas Guthrie, D.D. and Memoir by his sons, Revd David K. Guthrie and Charles J. Guthrie*, London 1875, vol.2, pp.417–19.

51 Obituary of Dr George William Bell, *Edinburgh Medical Journal*, 1889, vol.34, no.2, pp.772–3.

52 See Sara Stevenson, *Hill and Adamson's 'Fishermen and Women of the Firth of Forth'*, Edinburgh 1991.

53 Edgar March, *Sailing Drifters*, London 1952, p.226.

54 James Wilson, *A Voyage Round the Coasts of Scotland and the Isles in 1841*, Edinburgh 1842, p.160.

55 Captain John Washington, *Report on the loss of life and damage caused to fishing boats on the East coast of Scotland, in the gale of 19 August, 1848. Parliamentary Papers: Accounts and Papers*, 1849, vol.51, p.47.

56 Frances Ann Kemble, *Record of a Girlhood*, London 1878, vol.1, p.244.

57 Now in the British Library.

58 *The Witness*, 20 January 1844.

59 Hill to Roberts 12 March 1845, National Library of Scotland TD 1742.

60 Hill to Roberts 12 March 1845, National Library of Scotland TD 1742.

61 Quoted in Sara Stevenson, *Thomas Annan 1829–1887*, Edinburgh 1990, p.8.

62 Anonymous (presumed to be D.O. Hill), *The Disruption of the Church of Scotland: An Historical Picture*, Edinburgh 1866, p.3.

List of Illustrations

The photographs illustrated in this book are in the Scottish National Photography Collection at the Scottish National Portrait Gallery, Edinburgh. Unless otherwise stated, they were taken by Hill and Adamson in the years from 1843 to 1847. Many of them are undated. Where a date is known, this has been included.

Hill and Adamson principally used a camera which took pictures about $8\frac{1}{4} \times 6$ inches (21×16 cm) and, unless other dimensions are given, all of the calotypes illustrated here were taken with that camera. In the first year of the partnership they also worked with two smaller cameras, one of which took nearly square pictures about $4 \times 3\frac{5}{8}$ inches (9.5×9cm), and the other took pictures $6\frac{1}{8} \times 4\frac{1}{2}$ inches (15.5×11.5cm); the latter was used for the portraits of Hill with Chatty, Hugh Miller and Thomas Chalmers. In 1844, they purchased a camera capable of taking three larger sizes, up to 16×13 inches (43×33cm). The group of the Chalmers family was taken with this camera.

1. D.O. Hill and his Daughter, Charlotte
PGP EPS 90

2. Figures Dancing
Drawing by D. O. Hill
Pen, ink and pencil on paper,
11.3 × 24.3cm, D 4441
National Gallery of Scotland, Edinburgh

3. On the Quay at Leith
Painting by D. O. Hill
Oil on panel, 30 × 35.6cm, NG 210
National Gallery of Scotland, Edinburgh

4. The Harbour, St Andrews
PGP HA 338

5. The Harbour, St Andrews
PGP HA 296

6. Sir David Brewster
PGP HA 172

7. The Adamson Family
PGP HA 336

8. Revd Hugh Mackay MacKenzie
PGP HA 1450

9. Dr Thomas Chalmers, 1843
15 × 11cm, PGP HA 552

10. Hugh Miller, 1843
15.4 × 11.1cm, PGP HA 284

11. Greyfriars Churchyard
PGP HA 772

12. Dennistoun Monument, Greyfriars Churchyard
PGP HA 429

13. Sir William Allan
PGP HA 896

14. The Scott Monument
PGP HA 424

15. The Scott Monument
PGP HA 264

16. The Scott Monument
PGP HA 433

17. Jimmy Miller
PGP HA 410

18. John Ban MacKenzie
PGP HA 534

19. Dr Thomas Chalmers and his Family, October 1844
22.1 × 30.8, PGP HA 421

**20. The Marquis of Northampton,
28 September 1844**
Photgravure by J. Craig Annan after an
original by Hill and Adamson,
PGP HA 1744

21. Charles Peach, autumn 1844
PGP HA 1761

22. William Ettty, October 1844
PGP HA 382

23. Edinburgh Old and New
Painting by D. O. Hill
Oil on panel, 117 × 193cm, NG 1964
National Gallery of Scotland,
Edinburgh

**24. Reading the Orders of the Day,
August 1846**
PGP EPS 15

**25. 92nd Gordon Highlanders,
August 1846**
PGP HA 347

26. The Lodge at Bonaly Tower
PGP HA 2795

27. Colinton Manse and Weir
PGP HA 584

**28. Fence and Trees in Colinton
Wood**
PGP HA 425

29. Hill and Borthwick Johnstone
PGP HA 335

30. Horatio McCulloch
PGP EPS 134

31. Sir John Steell
PGP HA 381

32. Sophia Finlay and Harriet Farnie
PGP HA 2787

**33. James Ballantyne, Dr George Bell,
and D.O. Hill, 'Edinburgh Ale'**
13 × 19.4cm, PGP HA 435

34. Leith Fort Artillery
PGP HA 422

35. William Leighton Leitch
PGP HA 1323

**36. Mr Lane and Mr Peddie as
'Afghans' or 'Circassians'**
PGP HA 551

37. George Troup and William Gibson
PGP HA 423

38. Newhaven Boys
PGP HA 305

**39. Fishergate, North Street,
St Andrews**
PGP HA 299

40. Ellen and Agnes Milne
PGP EPS 91

41. Patricia Morris
PGP HA 2199

42. Mary Duncan
PGP HA 2775

43. Anne Chalmers Hanna, 1844
PGP HA 528

Further Reading

Bruce, David, *Sun Pictures: The Hill-Adamson calotypes*, London 1973

Ford, Colin, and Strong, Roy, *An Early Victorian Album. The photographic masterpieces (1843–1847) of David Octavius Hill and Robert Adamson*, London 1976

Michaelson, Katherine, *A Centenary Exhibition of the Work of David Octavius Hill 1802–1870 and Robert Adamson 1821–1848*, Edinburgh 1970

Stevenson, Sara, *David Octavius Hill and Robert Adamson. A Catalogue of their Calotypes in the Collection of the Scottish National Portrait Gallery*, Edinburgh 1981

—— *Hill and Adamson's 'Fishermen and Women of the Firth of Forth'*, Edinburgh 1992

—— *Light from the Dark Room: A Celebration of Scottish Photography*, with contributions from Robin Gillanders, James Lawson, Julie Lawson, Ray McKenzie, A. D. Morrison-Low and A. D. C. Simpson, Edinburgh 1994

—— *The Personal Art of David Octavius Hill*, London and New Haven 2002

Ward, John, and Stevenson, Sara, *Printed Light. The Scientific Art of William Henry Fox Talbot and David Octavius Hill with Robert Adamson*, Edinburgh, 1986